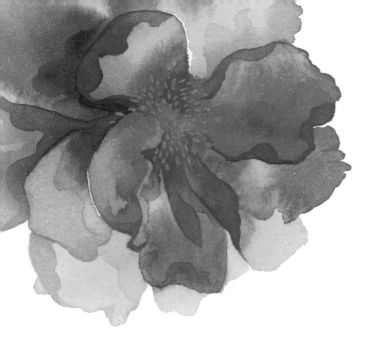

WATERCOLOR FLOWERS

Chinese Style

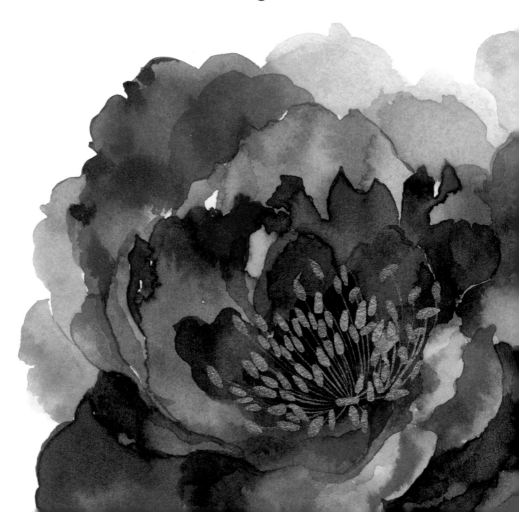

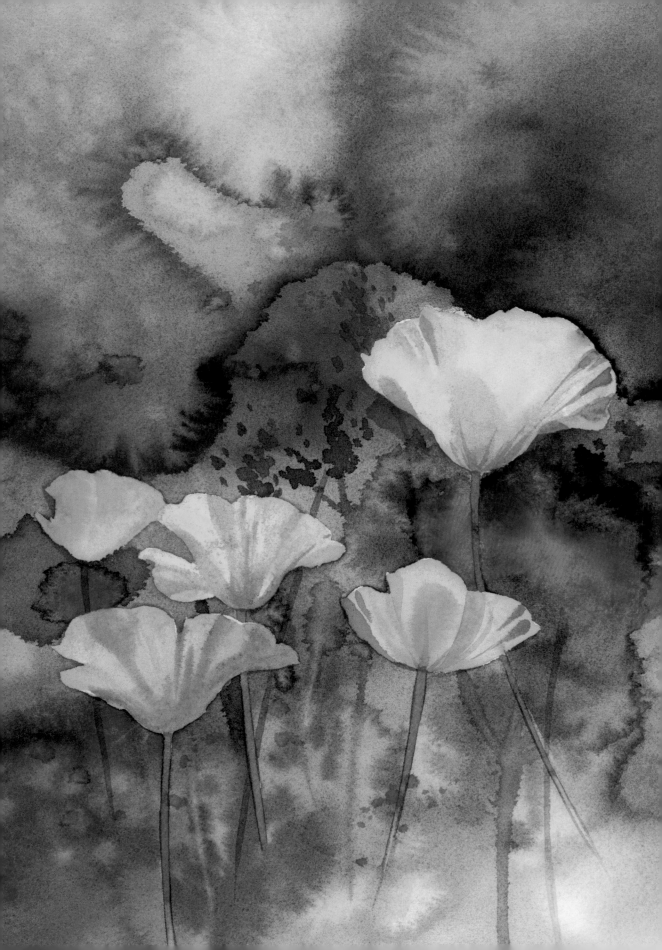

A Beginner's Step-by-Step Guide

WATERCOLOR FLOWERS
Chinese Style

By Lu He

Better Link Press

On page 1
In Full Bloom

The red and purple peonies are in full bloom, as if competing to be the most splendorous. The stamens are decorated with gold pigments, showing their elegant temperament.

On pages 2–3
Poppies

The orange poppies are even more colorful against the mysterious purple backdrop. The painting technique of lifelike contrast is used to highlight the flowers in the foreground while the technique of freehand brushwork is used to soften the flowers in the distance, and the contrast of cool and bright tones highlights the theme.

Bottom
Lotus Pond

The *liubai* (leaving blanks) technique from classic Chinese painting is employed to present a school of small fish swimming in the lotus pond. While there is no water in the picture, it allows the viewer to visualize a world of water. The elegant lotus flowers and leaves seem to be covered in a mist, ethereal and peaceful, like in a fairyland.

Text and Images: Lu He
Translation: Shelly Bryant
Cover Design: Wang Wei
Interior Design: Li Jing, Hu Bin (Yuan Yinchang Design Studio)

Editor: Cao Yue
Editorial Director: Zhang Yicong

Senior Consultants: Sun Yong, Wu Ying, Yang Xinci
Managing Director and Publisher: Wang Youbu

ISBN: 978-1-60220-046-3

Address any comments about *Watercolor Flowers: Chinese Style* to:

Better Link Press
99 Park Ave
New York, NY 10016
USA

or

Shanghai Press and Publishing Development Co., Ltd.
Floor 5, 390 Fuzhou Road, Shanghai, China (200001)
Email: sppd@sppdbook.com

Printed in China by Shanghai Donnelley Printing Co., Ltd.

3 5 7 9 10 8 6 4 2

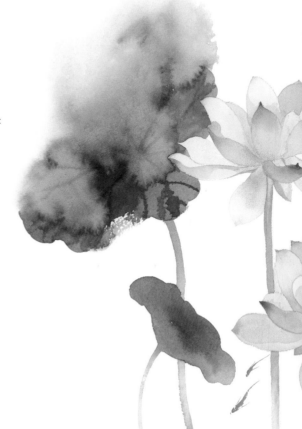

CONTENTS

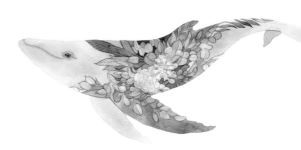

Top
Blue Whale
The lovely blue whale blends with the luxuriant flowers and branches, presenting a picture of playfulness and creativity. One is still, while the other is moving. The colorful light and shadow of the flowers seem to change with the swinging tail of the blue whale. The work emanates the charm and vitality of nature.

On page 6
Intoxication
The huge Chinese rose is hanging from the branches, intoxicating enough to entice one to pause and look. Blossoming in summer, the flower symbolizes happiness, beauty, peace, and passion in Chinese culture, echoing the heat of summer.

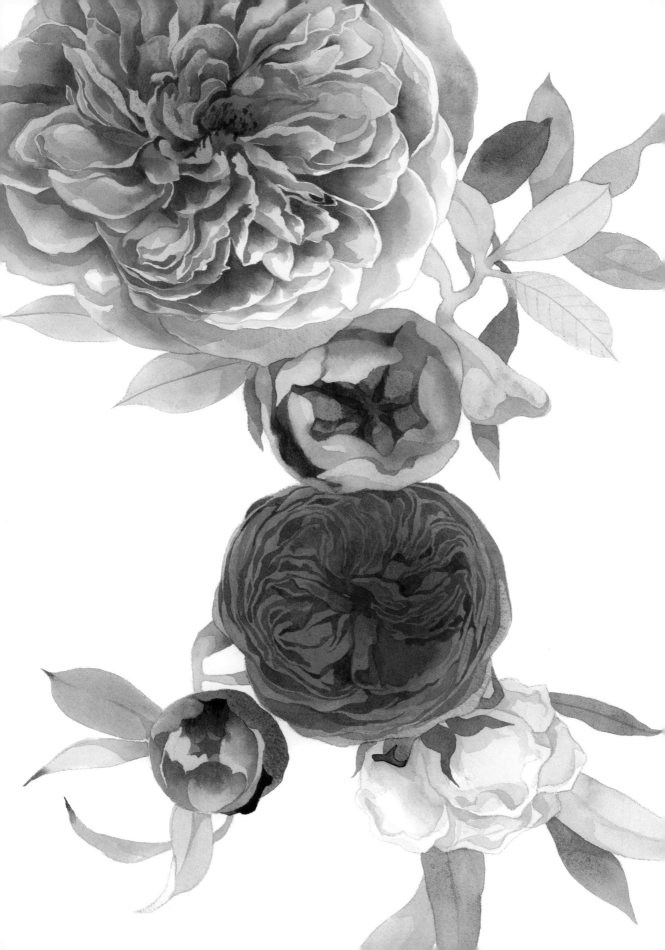

CONTENTS

Chrysanthemum
A blooming autumn chrysanthemum stretches its tender petals. In the painting, it seems there is a gentle breeze, making the flowers sway gently and rendering a refreshing feeling.

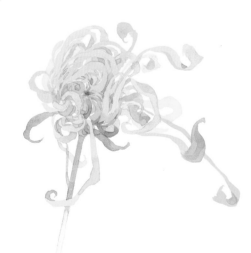

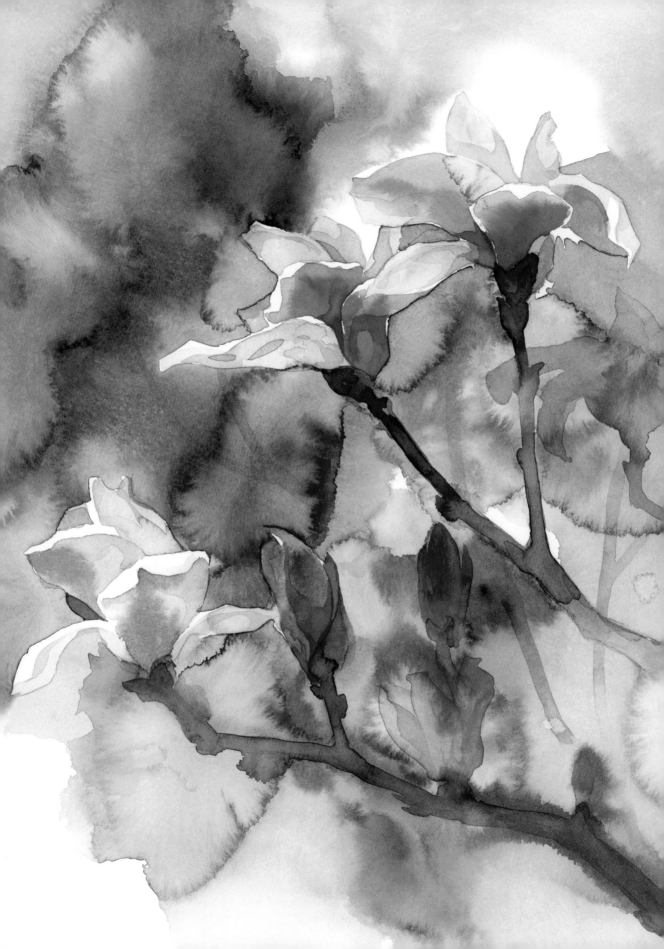

PREFACE
Embarking on Your Painting Journey with Ease and Pleasure

Since ancient times, the Chinese people have had a tradition of appreciating, extolling, and wearing flowers. Each season has its representative flowers, and at every moment of each season, countless beautiful flowers bloom around us and decorate every corner, causing us to stop and linger.

This book introduces 24 of China's popular seasonal flowers. They blossom in different periods, corresponding to the 24 solar terms in China. Depicted in flowing watercolors, they can be made to bloom on paper as well. From the initial outline sketch to the gradual coloring of the blossoms, and to the finalized flower, each of these paintings brings a floral feast of the changing seasons, with detailed text and step-by-step illustrations.

I started painting watercolors of flowers and plants about eight or nine years ago. At that time, I found that when I created works around this theme, I gained peace of mind, and the flowers presented would give viewers a sense of healing and pleasure, so I carried on with the theme until today.

In daily life, whenever I see my favorite flowers, I visualize how to draw them in way that highlights their characteristics and beauty. In the still life painting and creation in watercolors, my plan for the composition of a flower will be put into practice. By depicting flowers, I can convey my emotions and inner world, creating a dreamlike atmosphere and artistic conception. If you like to record your life through painting, you can observe your painted objects and make simple notes at all times. The simplest way is to take

On facing page
Magnolia
Magnolia is a common ornamental plant unique to China. In the painting, the pink and purple magnolias are all the more delicate against the colorful backdrop. It presents a scene of the recovery and vitality of all things in early spring.

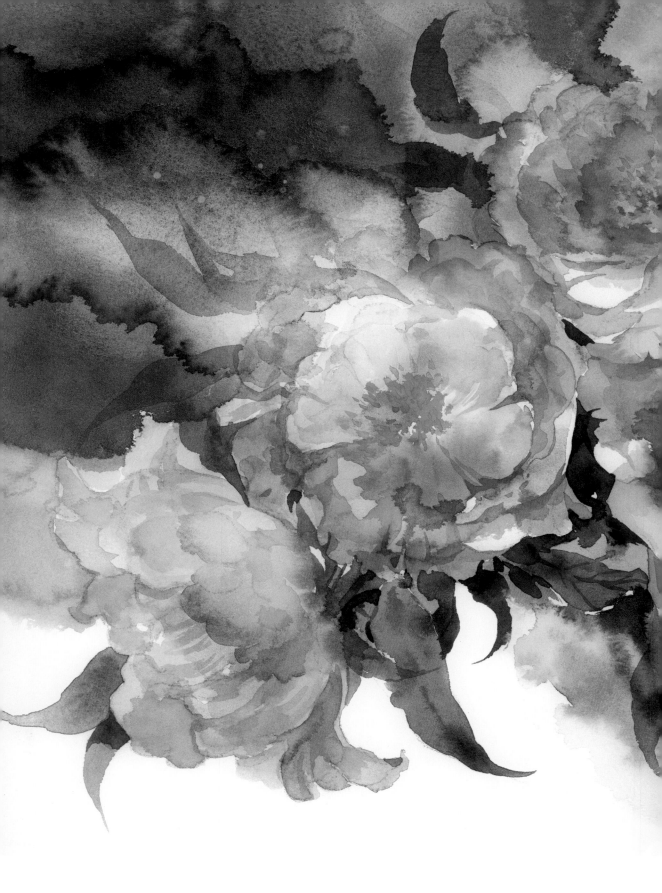

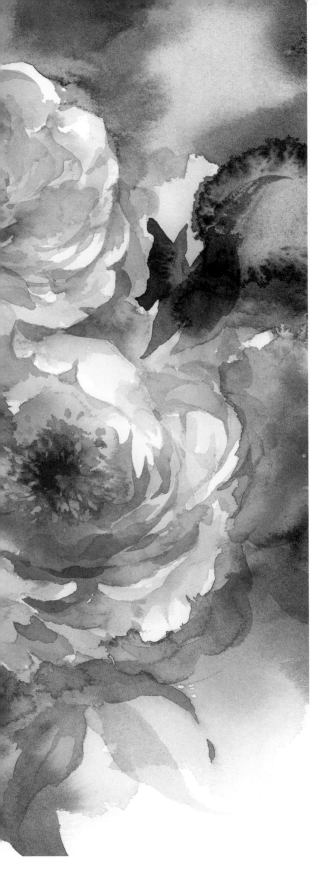

pictures of beautiful things with your camera, then put them into folders for future reproduction in watercolors.

In reproducing the works in this book, the reader can make his or her own bold attempts, without having to achieve the exact same effect. In the copying of the watercolor paintings, many factors will lead to differences in the final products. In particular, the free flowing and unrestrained traits of watercolor paintings will lead to differences between the individual paintings, because the flowing pigments change all the time. Even I can't draw another piece that is identical to the works I've produced here. One's preferences and aesthetic tastes are unique. You can draw your flowers in your preferred way and do the coloring with your imagination. In brief, you need to experiment, draw, and practice more, and eventually you will find the coloring habits and aesthetic tendencies that suit you best. The beauty of watercolor lies in its freedom from restrictions. Only when you start painting boldly and creating your own works can you really feel the joy of watercolor.

If you like painting and are interested in flowers, please open this book and start your painting journey with ease and pleasure.

Roses
A cluster of pink roses seems to climb out from the snow-white wall, causing the viewer to imagine a secret garden outside the picture, where "thousands of flowers bend the branches down, and lingering butterflies dance joyfully all the time."

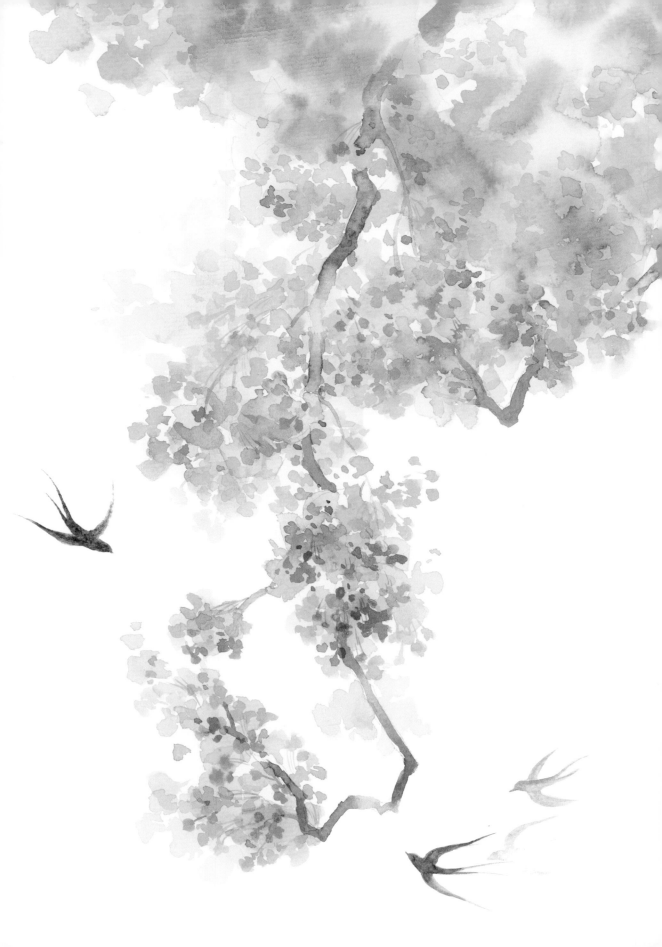

CHAPTER ONE
The Cultural Beauty of Chinese-Style Watercolor Flowers

China has one of the richest assortments of flower species in the world, with a long history of the domestication, cultivation, and utilization of flowers. In this long history of development, because of the increasingly close relationship between flowers and people's life, flowers are constantly included in Chinese people's thoughts and feelings, forming a cultural phenomenon related to flowers and a cultural system centered around them that is known as Chinese flower culture. In nearly three thousand years of history, Chinese flower culture has had a great influence on the development of Chinese literature, painting, religion, folk customs, medicine, textiles, crafts, and other fields, making a strong impression on every stage of Chinese history. It was no accident when a flower species rose to popularity in a particular historical dynasty, but a reflection of the characteristics of the times. For instance, people in the Tang dynasty (618–907) extolled the peony (see page 57 *Peony*). The elegance of the peony symbolized the prosperity of the Tang dynasty, and the people at that time viewed it as a symbol of wealth. Similarly, the plum blossoms loved by people in the Song dynasty (see page 109 *Plum Blossom*) reflected the spiritual pursuit and aesthetic ideal of the literati in that period (960–1279).

The watercolor painting course in this book not only integrates Western watercolor techniques with traditional Chinese painting techniques, making the watercolor flower style presented in this book unique and elegant, but also coveys the special meaning of Chinese flower culture and the significance of the flower culture built around the 24 solar terms.

On facing page
Chinese Flowering Crabapple
The Chinese flowering crabapple has been a widely popular flower in China since ancient times. It is crowned as a fairy among the flowers, with its charming look and lovely red buds. It is like rouge dotting the branches, drawing spring swallows to linger and stay. This flower has been a popular theme in Chinese poems and paintings throughout history.

1. The Beauty in the Rich Meanings of Flowers

Our ancestors wandered in the natural environment for thousands of years. They always looked at nature with a devout and appreciative eye, even personifying the flowers and plants they observed. They hoped that their personal creation could reflect and match the flowers and plants they held in their minds. The images of flowers and plants in people's minds are the embodiment of happiness, auspiciousness, and longevity.

Many traditional festivals in China are closely tied to flowers. For example, during the Spring Festival (the first day of the first lunar month), the oldest and most solemn traditional folk festival, people attach great importance to using flowers to increase the festive atmosphere, among which the daffodil (see page 113 *Daffodil*) is the most popular annual flower. During the Huazhao Festival (generally the 12th or the 15th day of the second month of the Chinese lunar calendar), people travel in groups to out of town locations to view flowers, which is called "going for an outing." Girls cut colorful paper and stick it on the flower branches, a custom known as "appreciating the colors," to celebrate the birthday of various flowers. During the Dragon Boat Festival (the fifth day of the fifth month in the lunar calendar), cloves, woody incense, angelica, and other herbs are put in sachets and hung on the body for the prevention of infectious diseases. The Mid-Autumn Festival (the 15th day of the eighth month of the lunar calendar) is when the sweet osmanthus (see page 91 *Sweet Osmanthus*) blossoms, so the sweet osmanthus and the bright moon become excellent objects for delight on this night of reunion, accompanied by delicious food such as sweet osmanthus wine, sweet osmanthus tea, and sweet osmanthus mooncakes. In the theory of traditional Chinese medicine, the chrysanthemum (see page 88 *Chrysanthemum*) has therapeutic and healthcare effects, giving it a reputation for being the "longevity-extending guest." Its blossoming coincides with the Double Ninth Festival (the ninth day of the ninth lunar month), and it is customary to enjoy chrysanthemums and drink chrysanthemum wine during Double Ninth celebrations.

There are also moving legends about flowers in Chinese myths and folktales, such as the lotus, which is viewed as one

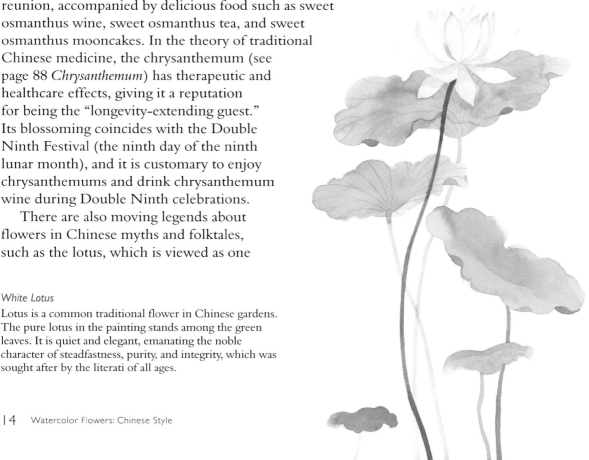

White Lotus

Lotus is a common traditional flower in Chinese gardens. The pure lotus in the painting stands among the green leaves. It is quiet and elegant, emanating the noble character of steadfastness, purity, and integrity, which was sought after by the literati of all ages.

of the twelve flower gods (see page 80 *Lotus*). Legend has it that the lotus is the embodiment of the beauty Xi Shi in the late Spring and Autumn period (770–476 BC), and the apricot flower (see page 53 *Apricot Blossom*) is seen as the incarnation of Yang Yuhuan (719–756), the imperial concubine in the Tang dynasty. Xi Shi, Yang Yuhuan, Diao Chan, and Wang Zhaojun are said to be the four beauties in ancient China.

In addition, flower culture runs deep in Chinese literature, music, and other fields. The beauty of flowers and the joy and artistic charm they bring enrich people's aesthetic tastes. Countless literati made flowers with the character and characteristics similar to their own personal pursuit, expressing their personal feelings and lofty aspirations through the description and praise of flowers, which gradually wove the beauty of the meaning of those flowers into Chinese culture, generating ideas such as the "three friends of winter" (pine, bamboo, and plum blossom), the "four elegant gentlemen" (plum blossom, orchid, bamboo, and chrysanthemum), and other beautiful images. People compare flowers to humans and vice versa, personifying the flowers. As a result, the purity of the water lily (see page 75 *Water Lily*), the perseverance of the plum blossom, the nobility of the peony, and the romance of the peach blossom (see page 46 *Peach Blossom*) remain parts of Chinese culture to this day.

2. The Beauty of Wisdom in the 24 Solar Terms

The ancients learned long ago that although all things in the world are unique, there seems to be similar breath and pulse in all living things, in that we all encounter birth and old age, prosperity and decline, change of seasons, and the ebb and flow of yin and yang. It was recognized that the activities and changes of plant germination, leaf development, flowering, fruit and leaves bearing, fading, and falling, and animals' dormancy, recovery, initial chirping, breeding, migration, and other activities are all subject to climate change, leading us to the concept of phenology, the natural phenomenon of flowers, trees, birds, and animals conducting regular activities according to certain seasonal changes.

The development of phenology serves as an important guide for people's lives, especially related to agricultural time. *Xia Xiaozheng*, dating from the Western Han dynasty (206 BC–AD 25), is the earliest phenology monograph in China. It records phenology, meteorology, astronomical phenomena, and important political and agricultural activities following the pattern of the 12 months in a year. The Qin dynasty (221–206 BC) Eclectics classic *Lü's Spring and Autumn Annals* and *The Books of Rites*, a Confucian classic of the Western Han dynasty, also contain similar phenological records. According to the phenological phenomenon, five days is regarded as one period and three periods as one solar term, which gradually developed into 24 solar terms and 72 periods a year. Today, the 24 solar terms, the wisdom crystallized through the long-term experience of working people, have been listed in the UNESCO intangible cultural heritage list. As a treasure of traditional Chinese culture, solar terms are not only limited to agricultural significance, but also

go deep into modern life, guiding people through ways to cope with seasonal and weather changes and develop a healthy lifestyle and diet, resulting in various solar terms activities and customs with local characteristics in the vast land of China.

This book connects my favorite flowers with the 24 solar terms according to their common blossoming periods. In describing the flowers, I note the characteristics of each solar term. I hope that the reader can enjoy the unique traditional Chinese culture in the process of learning Chinese watercolor painting.

3. The Beauty of Watercolors Integrated with Chinese Painting Techniques

Flowers are one of the main themes of Chinese painting, and paintings with flowers, birds, and insects as their object are one of the three traditional Chinese painting categories, collectively referred to as bird and flower paintings. Flowers have been depicted in China for a long time, but until the Spring and Autumn period, flower paintings were only used for the decoration of clothes, banners, and other utilitarian objects. In the Wei, Jin, and Northern and Southern dynasties (220–589), the number of artists working in flower painting gradually increased. In the Tang dynasty, Chinese flower painting saw a record number of famous artists working in the form, and complete Tang dynasty bird and flower screen murals have been unearthed in Xinjiang. This suggests that at that time, the bird and flower painting moved beyond a position subordinate to figure painting and became a popular genre in the court and among the people. During the period of the Five Dynasties and Ten Kingdoms (907–979), a large number of skilled bird and flower painters emerged, with Xu Xi and Huang Quan (?–965) serving as the representatives of two major schools, marking the maturation of Chinese flower painting. During the Ming (1368–1644) and Qing (1644–1911) dynasties, Chinese flower painting was quite innovative both in artistic conception and presentation techniques. Especially in the Qing dynasty, the works of the "eight monsters of Yangzhou" were mostly based on flowers, in a relatively free style unbound by general rules. As they were different from the orthodox painting style at the time, they were viewed as "monsters" in the painting world, thus the term "eight monsters." Their brushwork and ink techniques had a great influence on modern Chinese freehand flower painting. After the Qing dynasty, a large number of outstanding flower painters emerged in the field of Chinese painting. The most famous were Qi Baishi (1864–1957), Pan Tianshou (1897–1971), and Zhang Daqian (1899–1983), who creatively developed traditional Chinese flower painting.

When I turn to watercolor painting to express traditional flowers with Chinese sensibilities, I mostly use the boneless technique from traditional Chinese painting. The boneless technique is a technical name in Chinese painting, referring to the drawing of images directly with colors instead of drawing lines with ink. In the creation of watercolor paintings, I prefer to use the boneless technique to present the lightness and softness of flowers.

The character *mo* in the term *mo gu*, the Chinese word for "boneless," entails submergence and implication. The essence of the technique lies in the organic integration of the use of the brush and the setting of colors, without sketching or copying on the sample. When painting, the artist must be confident and have the entire picture in mind, integrating ink, color, water, and brush into an organic whole to present on the paper, focusing on the impression. The boneless technique sits somewhere between meticulous and freehand brushwork. Different from both the traditional rigorous, lifelike, and somewhat rigid meticulous brushwork and the unrestrained, hearty, and somewhat exaggerated freehand brushwork, boneless paintings have the characteristics of both, alongside its own distinctive traits, making it quite handy for painting either landscape or bird and flower paintings.

To create a watercolor painting with the boneless technique, in a popular sense, is to start drawing directly on the watercolor paper without sketches, having the desired effect and the intended feel roughly in mind from the beginning. With the entire picture in mind, one may start to follow the brush and finish the final painting. To make it easier for beginners to understand and learn systematically, most of the examples in this book have sketches to facilitate the learning and avoid errors. Those who have some painting background might want to try painting directly without sketches.

Corn Poppies
The colorful corn poppies (Beauty Yu) are charming and lovely. Her name is closely related to the ancient Chinese beauty Yu Ji. In the Chinese classic Peking Opera *Farewell My Concubine*, when Xiang Yu (232–202 BC), the overlord of Chu, was defeated in battle, before he died, he said farewell to his beloved beauty, Yu Ji, who committed suicide afterwards. It is said that a flower grows on Yu Ji's tomb, flipping even in windless air, like a beauty dancing, giving it the name Beauty Yu.

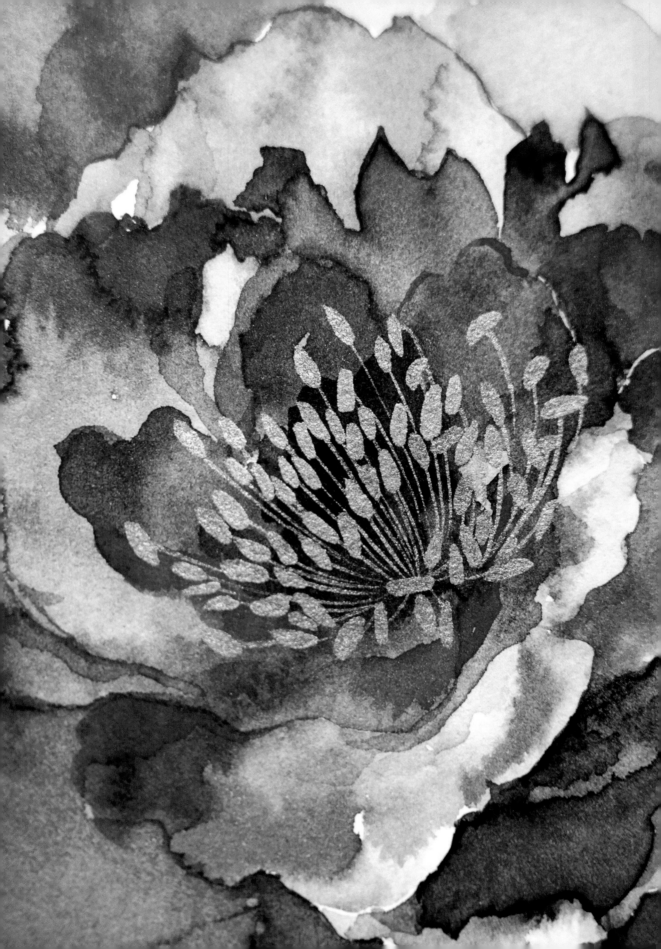

CHAPTER TWO
Tools and Materials

The basic tools and materials of watercolor painting are simple. You only need a few brushes, some paper, various pigments, and a palette to start your creation. With the mastery of painting skills, you can gradually add a variety of special auxiliary materials, such as masking fluid, salt, and a painting medium, which will infuse your painting with a sense of richness and unique effects. This chapter will introduce the basic painting tools, while the next chapter introduces basic skills that involve the use of some special materials.

1. Paintbrush

The brushes used for watercolor painting can be divided into two categories: traditional watercolor brushes and Chinese painting brushes, each made of either natural or artificial animal hair.

A brush made of natural animal hair is highly absorbent and moves smoothly and effortlessly across the paper. It can fully absorb the color and holds a good deal of paint with each dip of the brush. By contrast, artificial hair is hard and elastic, but not as absorbent, making it more efficient for depicting details.

Traditional watercolor brushes are usually made of sable or squirrel hair. I also paint watercolors with

Paint brushes.

On facing page
Details of *In Full Bloom*. Please see page one for the complete work.

traditional Chinese painting brushes, which are usually made of weasel hair or goat hair. Sable hair and weasel hair are both hard. I personally prefer this kind of hard hair because the strokes it makes are not too soft, making it handy for depiction. Squirrel hair and goat hair are both soft and have a large water storage capacity. Generally, I use these items to lay the background color or to shade a large area.

If the brush is used frequently, it will wear out in about half a year or a little more. If the brush is used for a longer period, it will become bald. But even old brushes can be used to draw dead branches, weeds, and rocks, or to splash or create texture effects, allowing them to be used to the best of their ability.

Tips for Choosing

Before painting, you can spend some time to choose the brush that suits you. For beginners, if you plan to buy more costly materials, you can prepare No. 4 and No. 6 sable brushes and a No. 2 squirrel brush to ensure availability of brushes for use in depicting both details and large areas of shading. Readers who don't plan to spend too much money on brushes can choose cost-effective brushes (one each in No. 2, No. 4, and No. 6) or high-quality mixed-hair brush and a goat hair flat-head brush. These brushes will meet the basic needs for painting. These are recommended brushes for paintings on an A3 size canvas. If the paper size exceeds A3, you need to get a larger brush.

At present, 90% of the brushes on the market are mixed-hair brushes, consisting of weasel or goat hair made of synthetic wool, hemp, or bristle, because pure weasel hair or goat hair are very expensive, and it is not easy to come by high-quality ones. Artificial wool, though, is cheap and elastic, and thus fit for beginners with small budgets. With average water absorption, it is also easy to control when painting. In choosing a brush, it is advisable to choose one with a rounded tip.

Many of the works in the book are created from beginning to end with No. 6 brushes. Personally, I prefer to draw from beginning to end with only one brush, as it can be done in one sitting without changing brushes, which interrupts the thinking and hand movements. For shading, you can prepare an absorbent No. 2 squirrel hair or goat hair brush to go along with the No. 6 watercolor brush.

Use and Maintenance of the Brush

A newly purchased brush generally contains colloid, which needs to be spread with lukewarm water to make the brush hair naturally spread out. After the hair is spread, wash it gently in the water to remove the floating hairs and impurities. Change the water several times, and then use tissue paper to dry the water on the brush head.

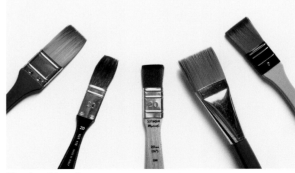

Flat-head brushes.

The brush must be cleaned after use or the paint will damage the brush hair and affect its duration. When cleaning, do not use too much force. After washing, try to use tissue paper to absorb the water on the brush head, then place it in a ventilated place. Immersing the brush in water for too long will shorten its service life. If the brush is not used for a long time, you can use egg white to seal it, coating the brush with egg white to dry it and store it in a dry place.

2. Pigment

Based on their characteristics, watercolor pigments can be generally divided into transparent and opaque watercolor pigments.

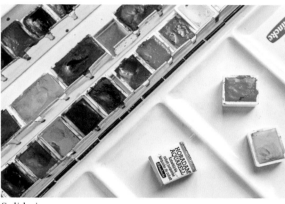

Solid pigments.

Transparent watercolor pigments have high transparency and diffusion. When colors overlap, the pigments in the lower layer will pass through. The light, transparent effect is very special, rendering the color bright and light. It is the kind of pigment I prefer to use.

Opaque watercolor has thick color and good coverage. When the color overlaps, it can easily cover the pigment below it. When coloring a large area, it is unlikely to leave uneven color or water marks. Generally, I prefer to use opaque watercolor to depict the details for modification or supplement. In this book, all the covering depiction of details (for example, depicting the yellow pistils on page 97) is completed with opaque watercolor. You can use two different watercolor pigments

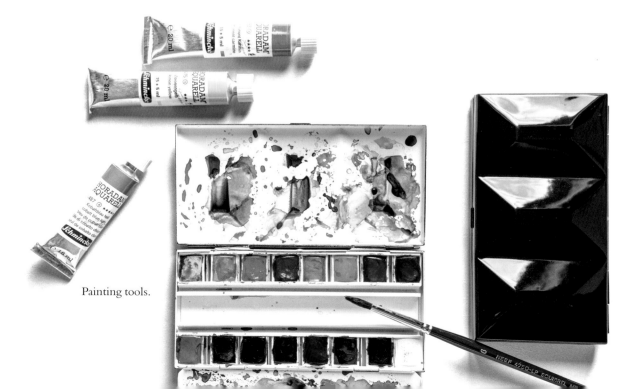

Painting tools.

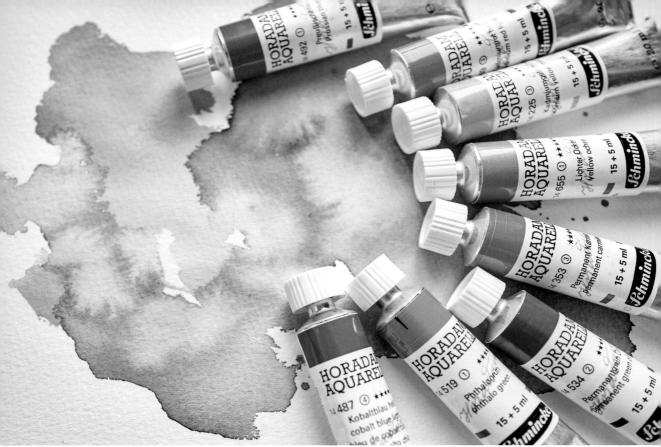

Tubular pigments.

according to your own needs.

In the production process, watercolor pigments are divided into tubular and solid pigments.

The tubular pigment is fluid and easy to take. In painting a large picture, it is used along with a color palette, convenient for color matching and mixing. It saves time and does not wear the brush. The disadvantage is that it is not easy to be carried around.

The solid pigment suits small paintings. It is easy to take and use. It spares time for squeezing pigments, and is easy to blend. The disadvantage is that some brands of pigments are too hard and difficult to take, so that if we rub the brush back and forth, the brush will be damaged.

Almost all watercolor brands have both tubular and solid pigments on the market. The solid has different sizes, including half block, whole block, and large plate. Each brand will have subtle differences. Some brands have also introduced watercolor sticks.

3. Paper

Watercolor paper is characterized by good water absorption, and it is also thicker than ordinary paper. The fiber on the surface is strong, not easily

Watercolor paper.

broken, or fluffy due to repeated painting. The common weights are 185 g, 200 g, 240 g, and 300 g, and there are also the less common 400 g and 640 g. The thicker the paper, the better the water absorption, and the less wrinkled it will be. However, it will absorb more pigment as well. After the color is dried, it will easily turn gray, not showing the original color. Among them, 300 g watercolor paper presents colors well and is not easy to wrinkle, so it is fit for most subjects, and thus most frequently used.

In terms of the material, there are two kinds of watercolor paper, cotton pulp and wood pulp. Cotton pulp paper absorbs water well, and its color will infiltrate into the cotton pulp fiber. It has good color rendering effects, and there will be no pilling when the color is mixed layer by layer. The effect of large-area shading is also beautiful. Cotton pulp paper can be used for paintings that need to be drawn carefully over a long time. But cotton pulp paper is expensive, not as economical as wood pulp paper. The latter is inexpensive and does not absorb water well, with pigment flow floating to the surface, but it is easy to create an impressive watercolor effect. If the water mark is properly handled, the painting will look very good. It is easy to scrub, fit for quick drawing, and if the shading is well managed, it will also be quite beautiful.

In terms of manufacturing process, it can be divided into hot and cold

Watercolor pad.

pressing. Based on the roughness of paper surface texture, it can be divided into coarse grain (cold pressing), medium coarse grain (cold pressing), and fine grain (hot pressing). The surface of the hot pressed paper is smooth and fit for capturing details, while the surface of cold pressed paper is rough, fit for displaying texture. On coarse grain paper, the color dries slowly, allowing one to draw slowly. The coarser the texture of the paper, the more likely there appears *fei bai* (a style of calligraphy characterized by hollow strokes, as if done with a half-dry brush), rendering a sense of freedom when creating various effects. On fine grain paper, the color dries fast, making it suitable for drawing subtle pictures. However, it needs to be managed promptly. Medium coarse grain paper is between the two, fit for drawing fine pictures without drying as fast as the fine grain paper. It's my favorite paper texture.

Even paper of the same brand can have a large price gap between looseleaf paper and watercolor pad. Because the process of making watercolor pad is more complex, it is usually much more expensive than looseleaf paper, but the difference in paper quality is not significant. Because I draw practically every day, I buy whole bags of looseleaf paper, which is more cost-effective. Readers who go out to sketch or draw occasionally can choose watercolor pad, which are convenient to carry and place. You can choose based on your own needs.

On facing page, top
Pigments in palette.

4. Palette

A palette is a place for storing, dipping, and mixing pigments when painting. There are a variety of palettes on the market. You don't need to be too particular in your choice. Simply choose one you like.

5. Other Aids

Silicone color shapers. This set of silicone color shapers has various nibs that can be easily dipped in masking fluid to draw flower stamens or details that need to be left blank. After use, the nibs can easily be cleaned. Twist gently with your hand, and the dry masking fluid will fall off. This allows you to avoid dipping your brush in the masking fluid, better protecting your brush.

 Kneaded eraser. After drawing the line draft, press and roll the kneaded eraser on the drawing to weaken the trace of the lines and make the picture more beautiful when coloring.

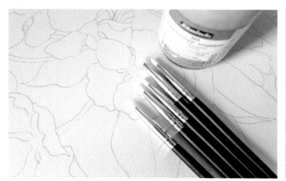 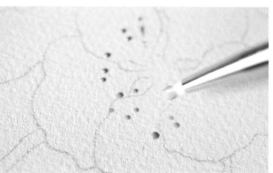

Silicone color shapers.

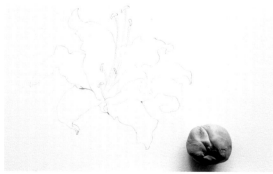 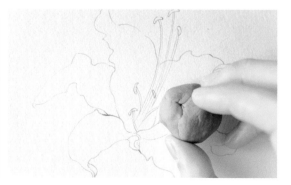

Kneaded eraser.

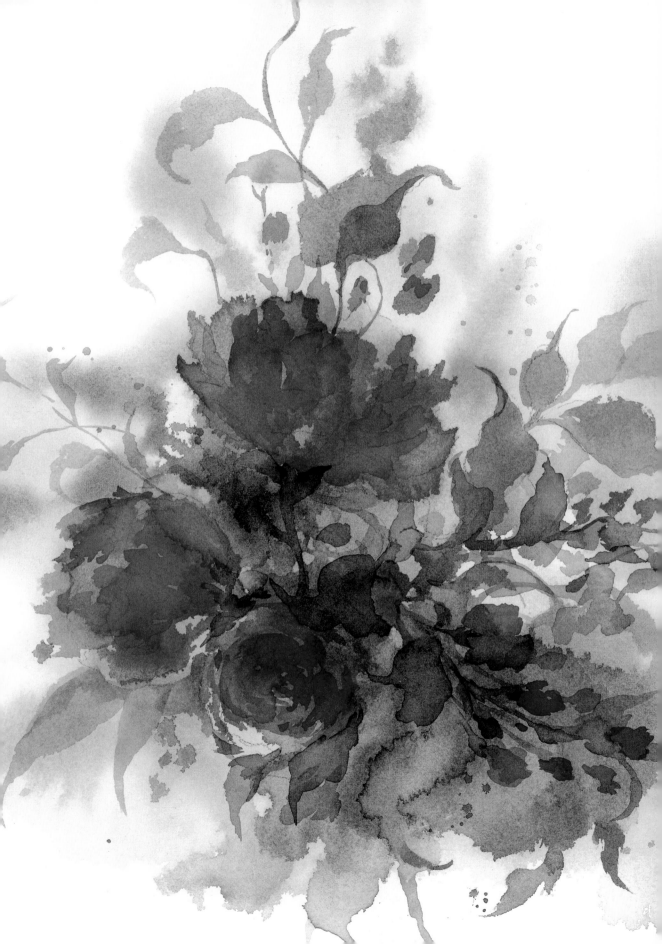

CHAPTER THREE
Basic Skills

This chapter will introduce some of the most basic skills of watercolor painting, which will be helpful for beginners who aim to get started quickly and go straight to the tutorial in Chapter Four. We have also designed some exercises for you to practice while learning.

1. Brush-Holding Posture

It is better to hold the brush tightly with the thumb, index finger, and middle finger, with the middle finger under the brush, so that it is easier to exercise the wrist or use the power of the fingers to control the brush. There is no absolute rule, so this is merely a suggestion. You can hold the brush in the most comfortable position for you.

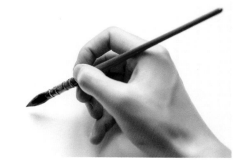

Brush-holding posture.

2. Method of Brush Movement

Centered-tip stroke: When drawing, we usually use the "centered-tip stroke" of the brush to draw. The lines and details drawn with the centered-tip will be clear and clean. When drawing, hold the brush tightly, make the tip of the brush perpendicular to the paper as much as possible, and use the

On facing page
Pomegranate Flowers
When summer comes, red-orange pomegranate flowers are scattered among verdant branches and leaves. Because of their rich colors and full fruits, people associate them with beauty, wealth, offspring, and happiness.

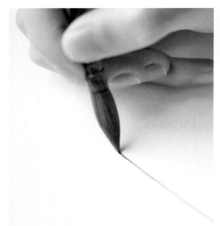 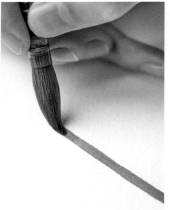 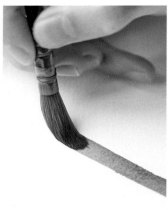

Centered-tip stroke.

 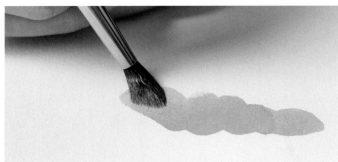

Side-brush stroke.

power of the wrist to drag the brush. Then you will see even, clean lines.

The thickness of the line will be different with the different pressure on the tip of the brush. This method can be used to draw the veins and branches of plants, so that the line presents a sense of rhythm. Lines made with the centered-tip stroke are more flexible, like flowing clouds and water.

Side-brush stroke: Dip in the paint and drag the brush with one side. This is called the "side-brush stroke." In color shading, the side-brush stroke

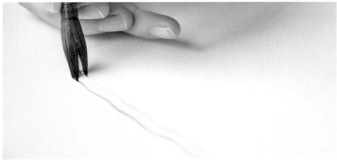

Creative stroke.

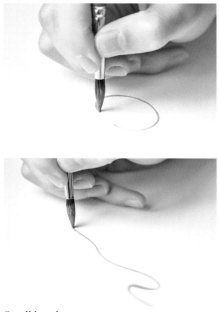

Small brush.

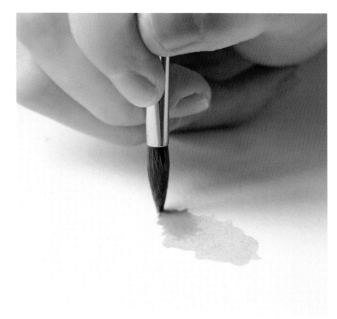

Medium brush.

is the handiest, so that the brush can contact the paper to a large extent, leaving beautiful traces between the color and the water. In flat coloring (see page 31), side-brush stroke is the most suitable, saving time and enhancing efficiency.

Creative stroke: In addition, you can use your hand to split the tip of the brush to draw interesting lines. Use your imagination to try more variations!

Using small brush: When selecting a brush, a brush with a small round head is more suitable for creating fine pictures. You can try using a small size brush to draw a fine curve or a circle.

Using medium brush: A medium tip brush can draw details and is also suitable for shading. If you do not want too many brushes and prefer to complete the picture with one brush, you can choose a medium-sized pointed brush. Now you can try using a medium size brush to draw a small pool of water.

Using flat-head brush: A brush with a flat head can draw even color blocks, as well as petals and leaves. You can try using a flat brush to draw a neat square.

Each person has different tastes and habits, so you can try various kinds of brushes to find ones that suit you best.

Flat-head brush.

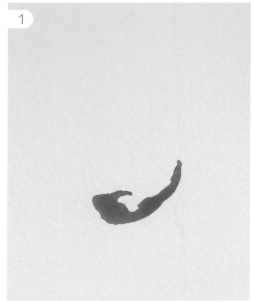

Try to alternate the use of the centered-tip stroke and the side-brush stroke with the different pressure of the brush tip, so that the lines produce different thickness for a petal.

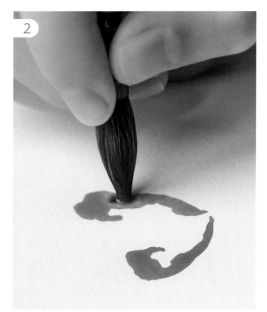

Increase the water on the brush, then draw the second petal by using the different strengths of the brush.

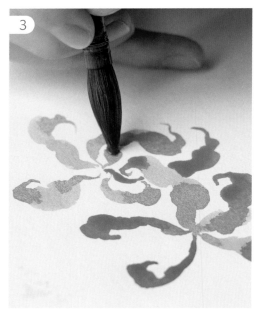

Continue to draw similar petals, adding more water to make the color change. Note that the more water, the lighter the color.

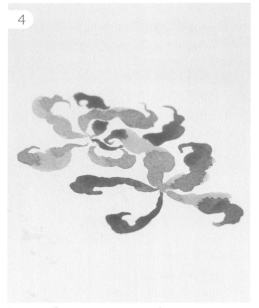

Draw two flowers in sequence, and pay attention to the color change at the overlap of petals. You can use your imagination and try to draw your own flowers with what you have just learned.

3. Basic Coloring Techniques

Coloring is a necessary skill of watercolor painting, among which flat coloring is the easiest for beginners.

Flat coloring: Use a flat brush or a round head brush, take sufficient pigment, and move the brush from top to bottom or from left to right quickly, with even force, so that the color block will be uniform and beautiful. Otherwise, the flat painted color will be uneven and unpleasant to the eye.

Dry stacking of colors: You can draw one color first, then draw another after that color is dry. Because watercolor pigment is more transparent, the color changes at the place where the two overlap, and a new color is produced. This is called dry stacking of colors, or wet-on-dry technique.

Wet joint of colors: Draw one color first, then add another while the first color is still wet. In this way, a wonderful gradient will appear at the intersection of colors. This is called wet joint of colors, or wet-on-wet technique. Most of the cases in this book are drawn using this technique.

If you feel the color of flat coloring is too uniform and want to create different picture effects, you can dip the brush in water, then drop the water vertically from a certain height to create the effect of "blossoming." The picture shows the effect of the dropped water.

You can also use a spray agent containing ethanol to give the painting an older look. The image on the right demonstrates the effect of spraying agent.

Flat coloring.

Dry stacking of colors.

Wet joint of colors.

Blossoming effect.

Effect of spraying agent.

Exercise: Dry Stacking and Wet Joint of Colors

With a round-head brush, draw a blue color first, and then a yellow color when the blue is dry.

Draw a blue color first, then a yellow one before the blue is dry. Feel the different effects of wet-on-dry and wet-on-wet technique.

4. The Shading of Color

Brush a layer of clear water on the paper first, then color it. Before the paint dries, drop other colors or clear water, and the new paint or water will slowly overlay and infiltrate with the previous color, producing the effect seen in the picture, which is also called a "water flower." This method can break the dreariness of the picture and increase the interest of the picture consciously or unconsciously. If used properly, this method can be used to draw abstract, hazy flowers in the distance, clouds in the sky, and the like.

The amount of water on the brush and the size of the spot area will affect the shape of the water flower. If you need a small water flower, you need a small brush with a lower water storage capacity. If you need a large water flower, you need a large brush with a higher water storage capacity. You may draw according to your own arrangement for this picture.

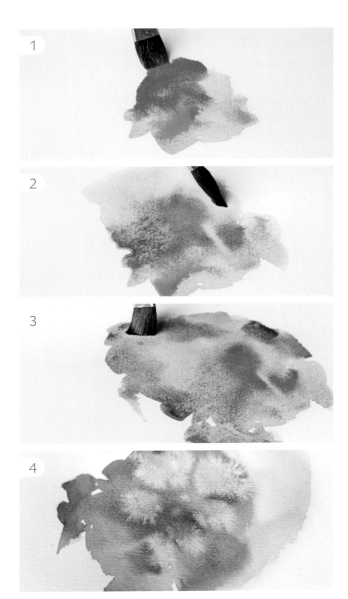

Exercise: Shading

Use different colors, and before the previous color dries, add other colors or water drops to see the superposition and infiltration of colors.

5. Use of Masking Fluid

Masking fluid is a tool to create special effects in watercolor painting, which is used to draw places on the canvas that need to be blank. There are different forms of masking fluid. Here we recommend a simple and convenient pen-type masking fluid. The specific steps are as follows.

1

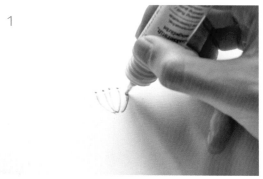

Simply use it as a pen, drawing a flower with pistils. Draw the part in advance with the masking fluid if you want to leave it blank.

2

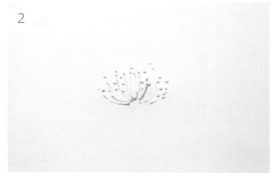

The drawing of stamen is finished with masking fluid.

3

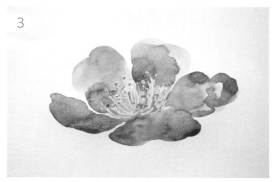

When the masking fluid is dry, draw the petals with watercolor pigment.

4

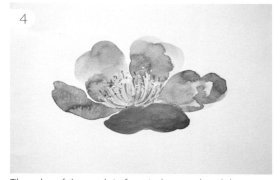

The color of the petals in front is deepened, and the contrast between the front and back of the petals is strengthened. Add details to the color at the stamen.

5

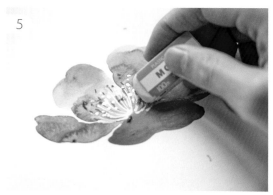

When the color is dry, use an eraser to remove the masking fluid.

6

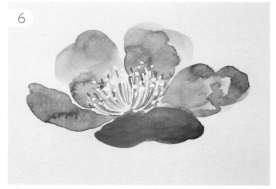

Clean the paper. The stamens and petals are complete.

6. Sprinkling Salt

Using the technique of sprinkling salt in a watercolor can produce different textures. If used properly, it can add a special flavor to the watercolor works, or it can be used with masking fluid to achieve various illusory and abstract effects.

Usage: When 50% or 70% of the pigment is dry and the water on the picture is no longer flowing, sprinkle the salt. You can choose crude salt, edible salt, or sea salt. You can try different sizes and categories of salt to see the various effects. Through practice, you will find the most suitable one for your picture. Sprinkle the salt and wait for it to dry naturally. Never use a blower to dry it, as it will damage the random effect of the picture.

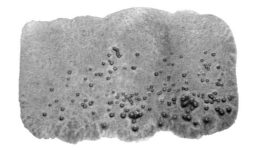

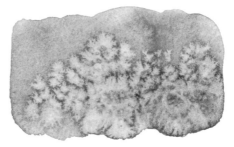

Effect of sprinkling salt.

7. Splash Technique

Pick up a brush, dip it in the color that needs to be splashed, and gently move the finger on the brush head, controlling the strength and direction to spray color dots of different sizes and directions. This is a common technique for giving variety to the texture.

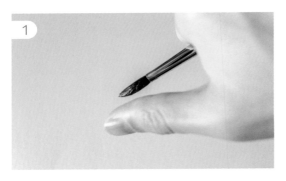

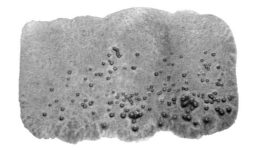

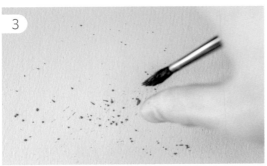

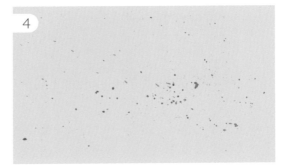

8. Other Special Effects

Usually, when creating a picture's background, we hope to have some special effects or textures. In general, we can control the water on the brush tip and the amount of pigments to create different effects, but we can also make special texture with the aid of precipitation agent or agents containing ethanol. You can spray the agent on the paper before painting, then wait a while to start. You will see amazing results. You can also use sharp objects such as scissors to make scratches. Boldly test the effects to make your picture more intriguing!

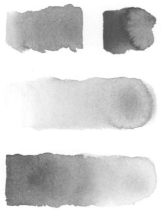

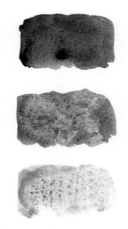

The image demonstrates the effects of different brush tip moisture. Darker colors mean less water, while lighter colors mean more water was used.

The image shows the different effects of different amounts of the agent. The more the agent, the lighter the color.

The image shows the scratch effect. Before drawing, first use scissors to scratch the paper, then color it. The image will emerge as is shown in the picture above.

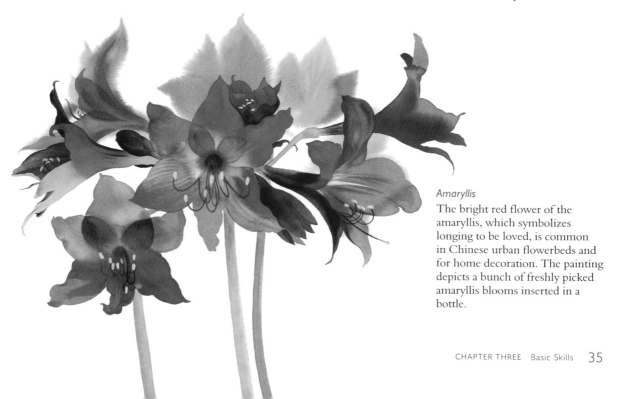

Amaryllis
The bright red flower of the amaryllis, which symbolizes longing to be loved, is common in Chinese urban flowerbeds and for home decoration. The painting depicts a bunch of freshly picked amaryllis blooms inserted in a bottle.

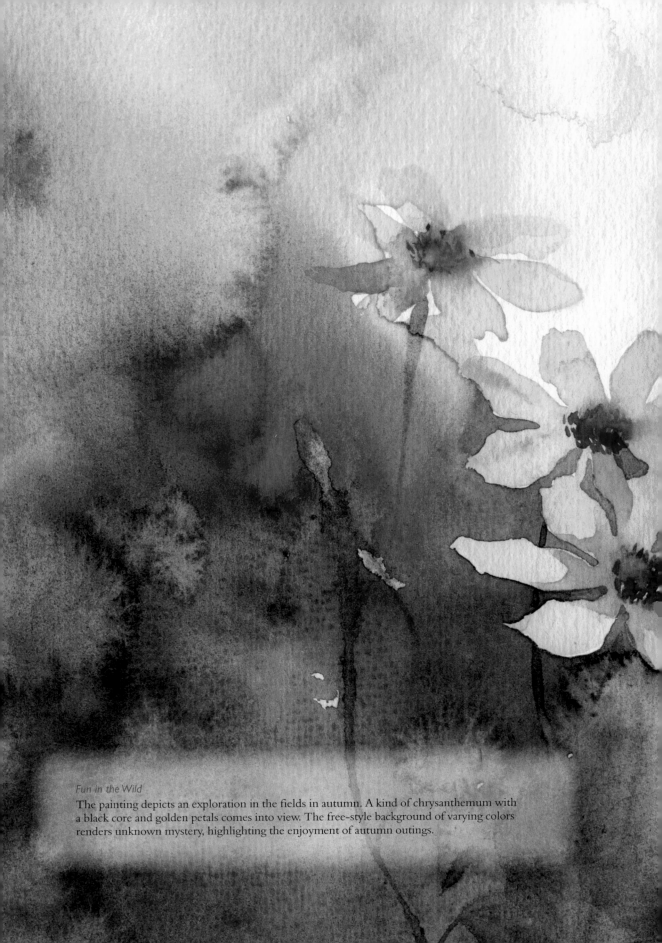

Fun in the Wild

The painting depicts an exploration in the fields in autumn. A kind of chrysanthemum with a black core and golden petals comes into view. The free-style background of varying colors renders unknown mystery, highlighting the enjoyment of autumn outings.

CHAPTER FOUR
Case Studies in Painting Flowers from the Four Seasons

In this chapter, I will lead you through the composition of 24 flowers using the techniques learned in the previous chapter. These 24 kinds of beautiful flowers not only display the beauty of the four seasons, but also correspond to the 24 solar terms used in the long history of China, presenting a unique cultural charm. Pick up the brush, follow my steps, and enjoy the beauty of the four seasons.

1. Winter Jasmine
(Start of Spring)

Start of Spring is the first of 24 solar terms. Falling sometime between February 3 and 5 each year, this day marks the beginning of spring. Everything is awake and burgeoning, the land is alive, and the air grows warmer.

At this time, the blooming winter jasmine smells fragrant and is golden in color. It usually blooms before its leaves grow. It is called the winter jasmine because it is the first to blossom among the spring flowers and does so as the others are only just beginning to bud, truly ushering in the spring. In China, it is known as one of the "four partners in the snow," along with the plum blossom, daffodil, and camellia, and has always been well loved (sketch on page 121).

1

Casually sketch with pencil, without too much detail. Wet the paper, color the flowers with a slightly thick yellow color, and mix with a little red orange to tint the backdrop.

2

Continue to mix a light-yellow color with lemon yellow, as you draw the flowers below and above.

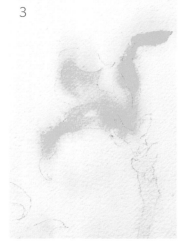

3

When the picture is 70% dry, start to carefully draw the flowers in yellow.

Depict the branches in Prussian blue mixed with burnt umber.

The branches should render the changes in color, rather than being the same thickness all along their length. Because there are many flowers in the center of the picture, the color of the branches near the flowers should be lightened with water, which will display the beauty of contrast.

Draw the shadow and turning part of the petals in yellow mixed with a little purple to create a three-dimensional perspective. The pistil can be decorated in red orange.

Refine the calyx of the uppermost flower, mix in brownish red at the tip of the calyx, and use another brush stained with water to color along it.

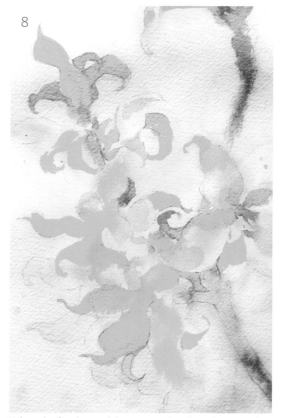

Some of the petals around the center of the picture are darkened in yellow mixed with purple.

When the first layer of the paper is dry, draw the second layer carefully in translucent yellow to darken the fading color of the first layer.

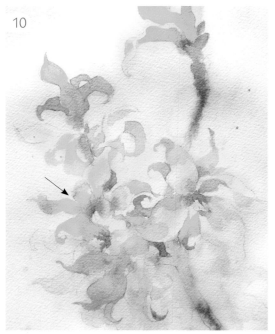

10

Mix purple with a little yellow, draw the pistils of the left flower (as shown by the arrow), and use this color to draw the shadow and turning part of each petal. Mix yellow with Indian yellow to form a strong orangey yellow to draw the details of the petals.

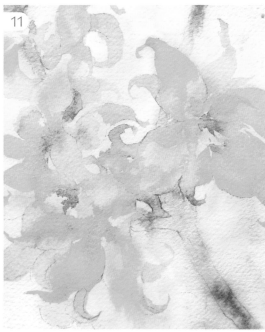

11

After the surface is dry, continue to use lemon yellow with high transparency and a little red to overlay on the petals, so that the petal levels will be richer.

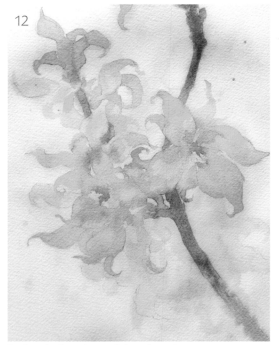

12

Darken the branches and the calyx in brown.

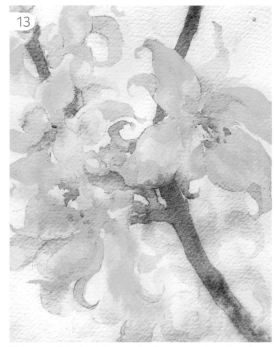

13

The part of the branch near the flowers can be painted mixed with a little Prussian blue to enrich the image. When you have drawn the details of the petals, the picture is complete.

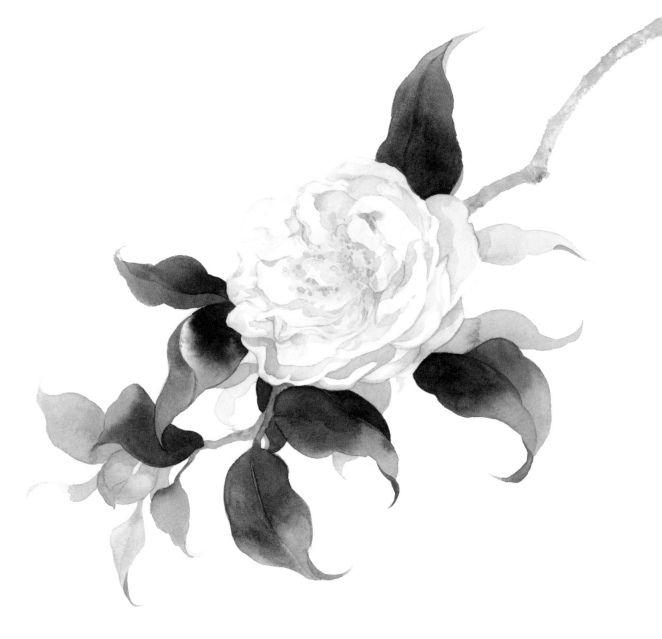

2. Camellia (Rain Water)

Rain Water is the second solar term in the 24 solar terms, falling between February 18 to 20 each year. At this time, with the gradual increase in rainfall, the drizzle covers everything with a poetic beauty. The temperature rises steadily, and the snow begins to thaw.

Camellias love the humid environment, so they bloom in the drizzle. The bowl-shaped petals overlap. The oil-green leaves stretch freely. The white camellia is even more pure and elegant, inviting people to love it. The camellia is one of the ten famous flowers in China. Since ancient times, the literati have loved its beauty and its character of "blossoming alone on early spring branches" (sketch on page 121).

1

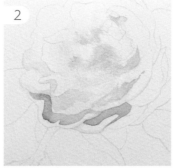

2

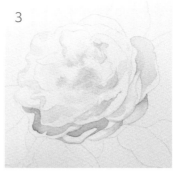

3

Use yellow color pencil to outline the line draft. Wet the flower center, and dye it with a little lemon yellow. Shade the petals with purple and yellow. Note to add more water to the purple, and the overall color should be light.

Draw the white camellia petals with the light purple remaining on the tip of the brush, and note that the color should be light.

Though they are white petals, the flower will have various changes under the light. Therefore, the light purple and light ultramarine blue are used to draw the shadow and turning part of the petals.

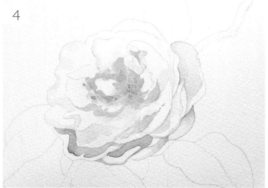

4

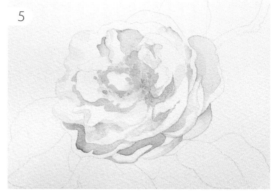

5

Dip in the warm medium yellow, and use a brush with a round head to color the pistils. Dip another brush in clean water to dye the flower core. Note that although the pistils are small, they are connected as a whole image. Highlight the details with orange red dots.

To make the white camellia present a colorful luster, continue to draw the shadow of petals with the mixed color of Prussian blue, lemon yellow, and medium yellow. And mix purple, Prussian blue, crimson, and yellow to draw the petals near the core.

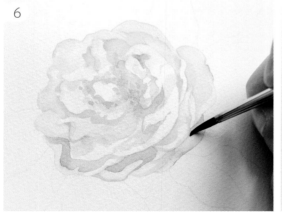

6

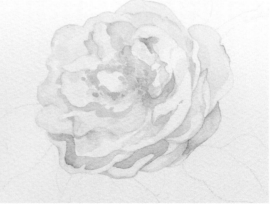

Shade the petals on the outer layer with a light blue color to create a contrast between the warm and the cold and a dimension between the front and the back. Then draw the petals closer to you. Use clear water and rose red to shade and dye lightly. Be careful not to paint flat, but to paint a three-dimensional perspective with color variation.

7

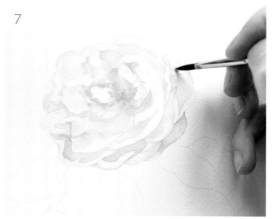

Continue to draw blue shadow details with small strokes.

8

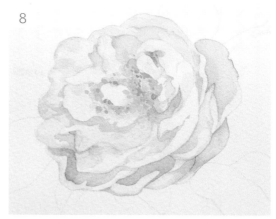

At this time, the main part of the flower has been largely completed. You can use orange and red dots to draw the flower core to enrich the details.

9

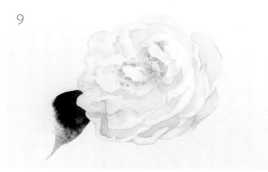

The leaves are painted in dark green, ochre, and Prussian blue mixed together. Note that the color of the leaves near the flowers is the darkest, and the dark edges are shaded with water.

10

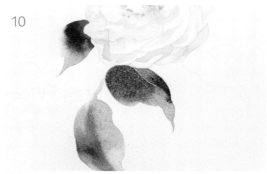

The lower leaves are blended with golden ochre, dark blue, dark green, and leaf green to display different shades. The leaves near the flowers are darker in color, highlighting the white of the flower. In addition, a white space should be carefully set aside at the vein of the leaf in the middle, and the turning point of the leaf should be drawn in a cool green color.

11

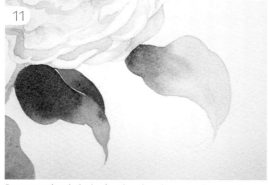

Draw another light leaf with ochre, lemon yellow, and Prussian blue.

12

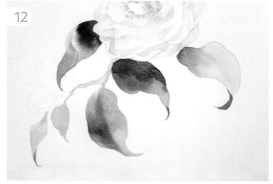

Because the petals need to present colorfully lighted white, the color of the leaves should be rich and harmonious. The leaves farther away from the flower should be painted with light earth red, Prussian blue, and a little lemon yellow. Use leaf green and dark green to draw the back of the curved leaves, presenting a three-dimensional perspective.

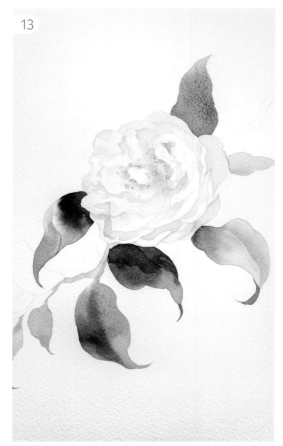

13

Continue to draw leaves above the flower with lemon yellow, leaf green, and phthalo blue.

14

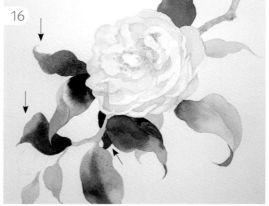

The flower branch is painted with the color of ochre, Prussian blue, and burnt umber. Deepen the color at the turning point of the flower branch to highlight the dimensions.

15

The leaves on the back of the flowers are farther away. Simply dye them with a light shade of light ultramarine blue.

16

Use the leaf green, phthalo green, and lemon yellow to mix into a lively dark green to draw two more leaves on the left side of the camellia and one more leaf on the back. The leaves of a camellia are thick green, but they can be created with the painter's subjective consciousness in the paintings. The two leaves here are painted in such a strong green to highlight the main body of the camellia.

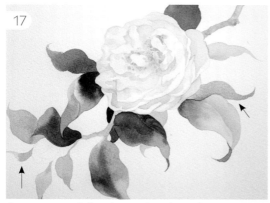

17

Continue to use light colors to draw distant leaves.

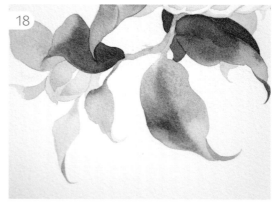

18

The flower bud in the lower left corner can be painted with the color of the surrounding leaves, so that the color will be harmonious and unified.

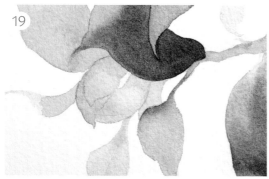

19

Add water with the color of rose red, ultramarine blue, and sky blue to enrich the color of the flower bud. After drawing the flower bud, you can add a little ultramarine blue to draw the shadow of the flower bud part blocked by the leaves, which can be presented in a light way.

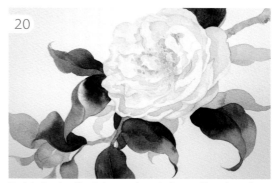

20

Enrich the details of the petals with the small strokes of a small brush, distinguish the light receiving surface and the shadow of the petals with the thickness of the color, and emphasize the contrast. The colors should be light.

21

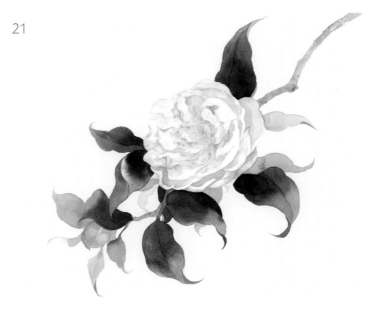

The camellia is complete.

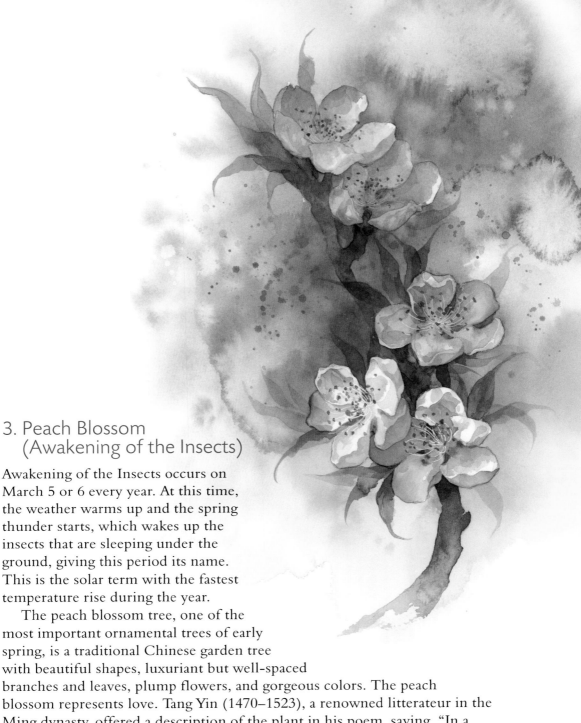

3. Peach Blossom (Awakening of the Insects)

Awakening of the Insects occurs on March 5 or 6 every year. At this time, the weather warms up and the spring thunder starts, which wakes up the insects that are sleeping under the ground, giving this period its name. This is the solar term with the fastest temperature rise during the year.

The peach blossom tree, one of the most important ornamental trees of early spring, is a traditional Chinese garden tree with beautiful shapes, luxuriant but well-spaced branches and leaves, plump flowers, and gorgeous colors. The peach blossom represents love. Tang Yin (1470–1523), a renowned litterateur in the Ming dynasty, offered a description of the plant in his poem, saying, "In a peach blossom recess stands a peach blossom temple, in which lives a peach blossom immortal, who has planted peach trees and picked their fruits for wine money. He sits in front of the flowers when sober and takes a nap there when drunk." This verse depicts an exceptionally carefree, romantic state (sketch on page 122).

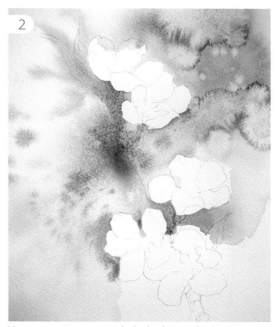

First draw a sketch in pencil. Wet the paper with plain water on a large brush (goat hair flat-head brush or No. 2 brush), leaving the flower part blank. Let the colors of leaf green, rose red, ultramarine blue, Prussian blue, phthalo blue, and turquoise drop casually and randomly onto the paper so that the pigment can be naturally fused and infiltrated.

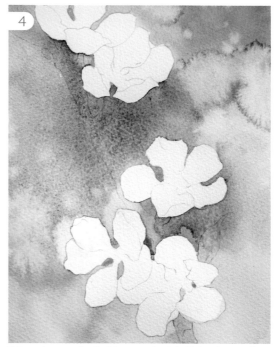

You can continue to enrich the background color. When the background color is drying, add a few drops of water to create a water mark effect. Near the edge of the petals, use turquoise and rose red to draw vague petals to present the images only, without specific detail.

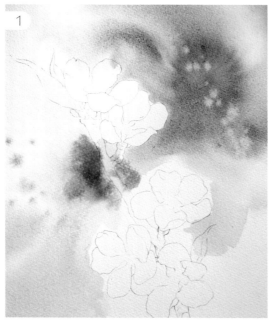

Add color under the flowers with turquoise. Be careful not to cross the lines into the flowers. If there is excess water, you can use a tissue to carefully absorb the excess water and color.

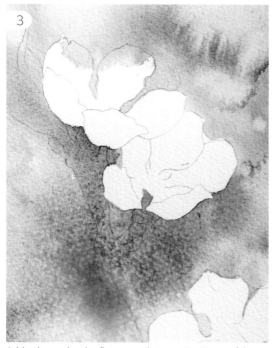

When the part dyed with turquoise is half dry, drop in the mixed leaf green and lemon yellow.

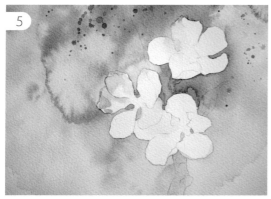

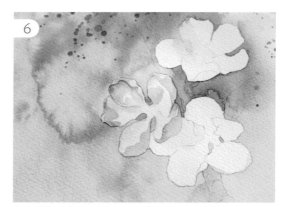

When the background color has completely dried, dip the brush into green and blue, then randomly splash paint spots around the flowers. Then start drawing petals. Mix rose red with a little ultramarine blue, and dye each in turn, from the petals to the center of the flowers.

In the flipped parts of the petals, you can add a larger proportion of ultramarine blue to the mixed color for drawing. The quieter bluish purple will make the petals look more three-dimensional.

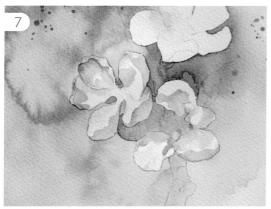

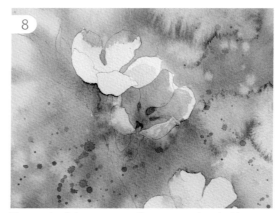

The lower flower is painted in fuchsia. In the shadowed part blocked by the upper flower, add a small amount of ultramarine blue and turquoise blue.

The petals of the two upper flowers are painted with a quiet purple color by mixing rose red and ultramarine blue. Blend in a little sky blue near the shadow where the two flowers overlap.

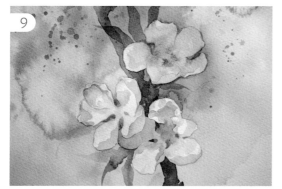

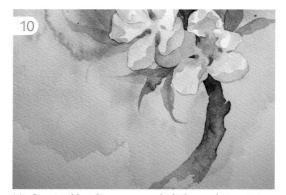

You can draw in the leaves now, keeping them flexible. Blend the leaf green, dark green, sky blue, and lemon yellow to draw the transparent-looking leaves. When the petals are colored, the core part of the flower is painted with lemon yellow, and the space between the petals can be painted with a mixture of lemon yellow and leaf green.

Mix Prussian blue, Payne gray, and a little purple to paint the branches. Add more blue to the branch part that are covered with flowers.

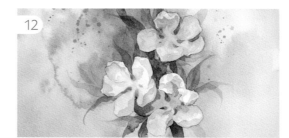

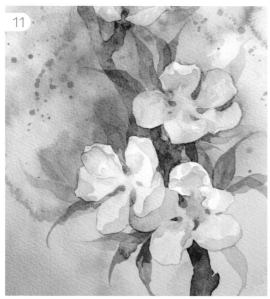

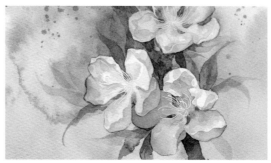

As the flower becomes more solid, the peach leaves should remain vague, highlighting the contrast between the solid and the vague. When drawing the leaves, add more water to create a sense of transparency. When the second layer of color is placed on the leaves, use pigments with higher purity to draw the flipped parts of the leaves. The background around the flowers is shadowed with turquoise.

The top flower petals are painted with a mixture of ultramarine blue and magenta. In the shadow of the overlapping petals of the two flowers below, use thick purple and rose red for drawing. Draw the edge of the petals directly with highly saturated rose red, then lighten with clear water. The colored area should not be too large. Use opaque white to draw the pistils of the peach blossom. The lines of pistils should be soft and stretching.

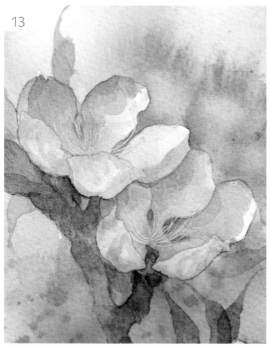

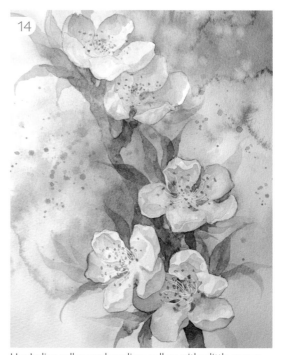

On the surface of the peach blossom petals facing the light, draw carefully in light purple mixed with water to highlight a sense of dimension. Draw the pistils of the two upper flowers with the same opaque white.

Use Indian yellow and medium yellow with a little orange red to enrich all the stamens. The painting is complete.

4. Purple Magnolia (Spring Equinox)

The Spring Equinox is between March 20 and 22 each year. It is not only of astronomical significance, the equinox between the northern and southern hemispheres, but also has obvious climatic characteristics. When the Spring Equinox arrives, the climate is mild, the rain is abundant, and the sun is bright.

Purple magnolia is a unique plant in China, with bright blossoms, elegant fragrance, charming shapes, and abundant branches and leaves. It is both a traditional flower and a type of traditional Chinese medicine with a long history in China. Its bark, leaves, and flower buds can be used as medicine, which makes it a very precious flower (sketch on page 122).

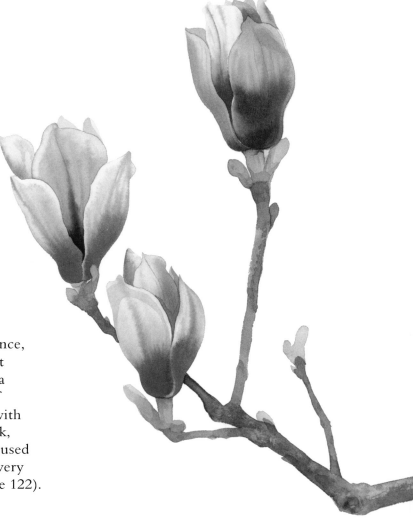

Mix rose red and ultramarine blue to make purple red. Add a lot of water, and draw the first petal of the magnolia.

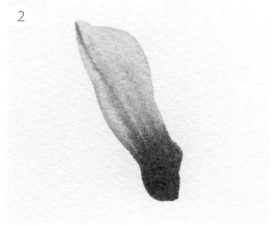

The bottom of the petal is painted with a stronger purple red color. Brush quickly from the bottom to the tip of the petal, showing the three-dimensional perspective of the petal.

3

4

5

Use the same method to draw the second petal. After the petal is completely dried, use a brush dipped in water to rub repeatedly and wash the color from the upper edge of the petal. The petal will present a three-dimensional feeling.

When drawing the second flower below, you can mix more ultramarine blue in the purple red to distinguish it from the color of the first flower.

Draw the third purple magnolia. Mix rose red and ultramarine blue, with more rose red.

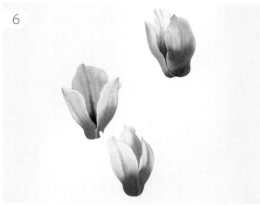

6

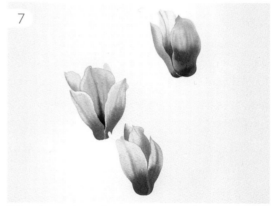

7

After the petals on both sides are dry, you can draw the middle petal for three flowers, which is shaded and dyed from the thick purple red of the root. The texture of the petals should also be drawn.

When the petals are dry, continue to use the shading method to supplement the petals of each flower.

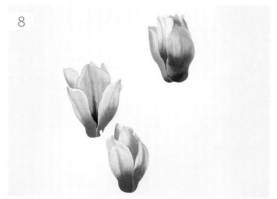

8

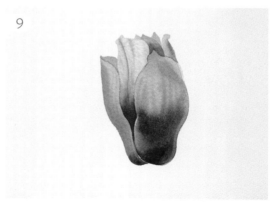

9

Replenish all petals. When the flowers are dry, the shadows on the petals can be added, and the high transparency color can be used to apply layer upon layer.

Thinking of the petals as a sphere, draw a three-dimensional perspective on the surface of the flowers with purple red. The closer to the center, the denser the color will be. The edges of the petals are shaded with a brush dipped in water to make the color lighter.

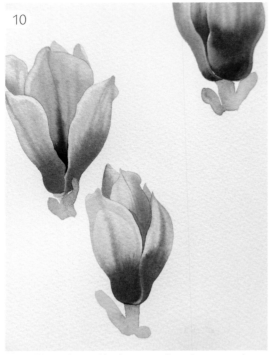

10

Mix golden ochre and leaf green to draw the receptacle. Add orange red shading to the top of the receptacle.

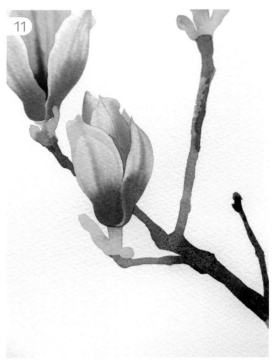

11

Draw the stem with Payne gray, and add a little mixture of ultramarine blue and rose red to the stem near the bottom.

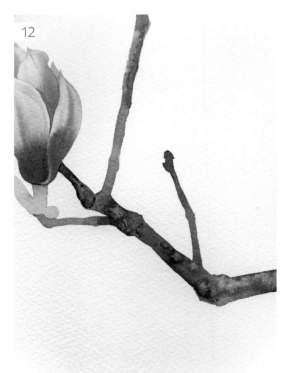

12

When the branches are 70% dry, drop clear water on the edge to create a water mark effect, giving the branch a mottled, undulating texture.

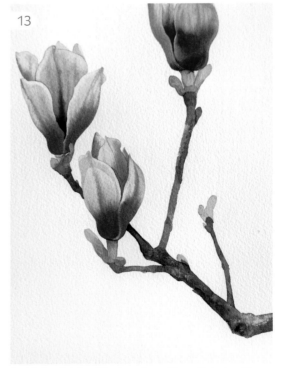

13

Enrich the details of the branches with small strokes. Dye the buds with green. The painting is complete.

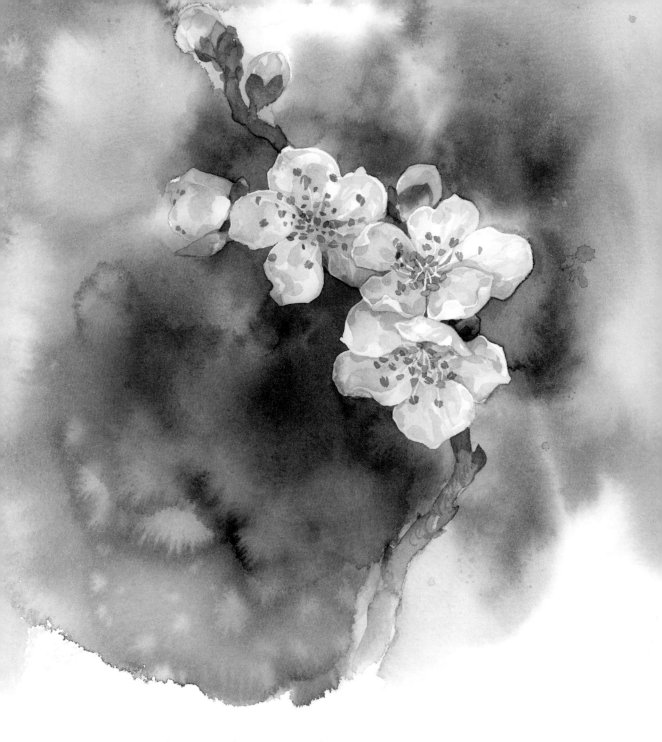

5. Apricot Blossom (Qingming)

Qingming is around April 5 every year, which is the only day that is both
a solar term and a traditional Chinese holiday. During Qingming, the
weather is clear and bright, which is what the term "Qingming" means. It is
customary to sweep tombs to worship ancestors and to arrange outings in the
countryside.

Apricot blossoms are ancient flowers and trees in China. It is recorded in *Guanzi*, from the Spring and Autumn period to the Qin and Han dynasties (221 BC–AD 220). This means that its history of cultivation stretches back at least 2,000 years in China. The flowers are red or white, luxuriant, elegant, and eye-catching in spring. Apricot blossoms often change colors. When they are in bud, they are bright red. With the spreading of petals, the color changes gradually from thick to light, then becomes white when the blossoms fall. Because of its beauty, the apricot blossom symbolizes a lovely girl, and because of its homonym with the word "luck" in Chinese, it implies joy and happiness (sketch on page 123).

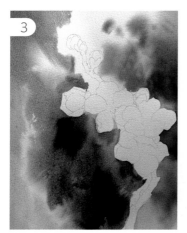

Draw the outline with pencil.

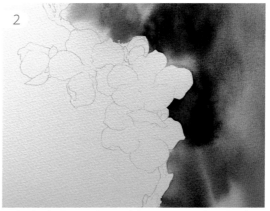

Make the background part of the paper wet, then dip the large brush in a mixture of ochre, ultramarine blue, Prussian blue, and a little phthalo blue to render the background on the right. Drop turquoise on the edge of the flower to make the solid background more transparent.

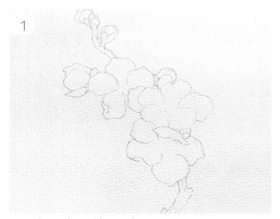

Continue to render the background on the left side with a mixture of Payne gray, sea green, and burnt umber, making sure not to touch the petals.

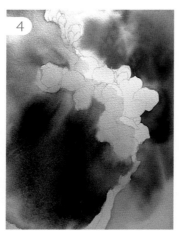

Dip another clean brush in clean water and dye the petals. The color will merge and make the boundary between the petals and the background softer. The part softened by water is the backlight of the flower. Do not dye the entire petal.

Mix turquoise into the background color, managing the intensity according to your own preference. When the background is 70% dry, use a large brush to drop water to create a water mark effect.

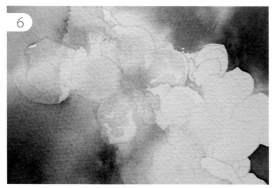

When the background is completely dry, draw the petals of the first flower with the diluted ultramarine blue. Mix purple in the flower core as a final touch.

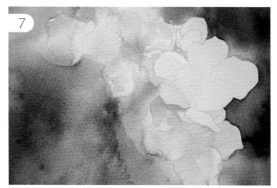

Draw the flower at the bottom. Pay attention to the part covered by the flower in the middle. The color should be a little thicker to show the shadows. However, the whole flower should be light, but can be deepened gradually. The lower petals can be mixed with a little sky blue on the foundation of the ultramarine blue.

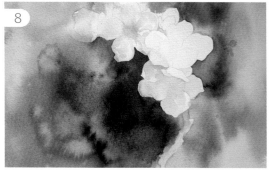

Use a mixture of strong green, Prussian blue, Payne gray, and raw umber to draw a clear distinction between the background and the petals. Use another clean brush to expand the background color to the outside, leaving out the branch. The boundaries between the petals and the background can all be colored in this way, with the color near the flower being thicker.

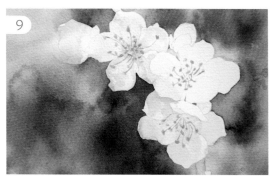

When all the pictures are dry, you can use a silicone color shaper dipped in white masking fluid to carefully draw the pistils, with varying density.

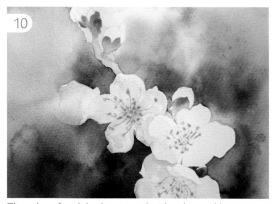

The calyx of each bud is painted with ochre and burnt umber. A little earthy red can be added to create subtle variation.

After drawing the calyxes, you can mix the remaining paint on the brush with a little purple to draw the branches. It can be mixed with ultramarine blue and earthy red to draw the twisting branches to create a three-dimensional effect, varying the lightness of the color.

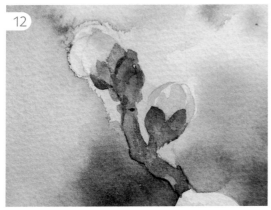

Blend blue to draw the upper branches and enrich the color. Continue to enrich the details of the branches with Payne gray and brown. Draw the flower buds with ultramarine blue, rose red, and turquoise.

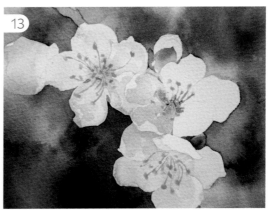

Paint the petals of the flowers in the middle with a mixture of Payne gray, ultramarine blue, and rose red. The part near the core can be dyed with a reddish purple.

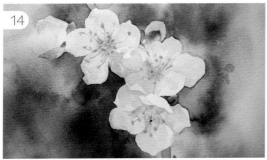

Continue to draw the petals of the middle flower, making sure not to paint too flat. Rather, increase the transparency to bring out the color. Show the three-dimensional feel of the petals, varying light and shadow with the change of color lightness, and deepening the color where the shadow is to be shown. The overlap of the middle flower and the upper flower petals is painted with purple, which is then blended with ultramarine blue on the upper flower petals.

Draw the detail and shadows on the branches with small gray strokes to make the flat branches look three-dimensional. Don't drag the brush when painting but instead, draw with a brisk, crisp touch to highlight the beauty.

After the first layer of petals is dried, lightly enrich the details of the petals with purple and ultramarine blue.

When the picture is dry, wipe off the white masking fluid from the filament with an eraser. Draw the anther of the first flower with strong yellow and earthy red, varying the color. Use strong yellow, medium yellow, leaf green, and lemon yellow to draw the anthers of the two flowers below. The painting is complete.

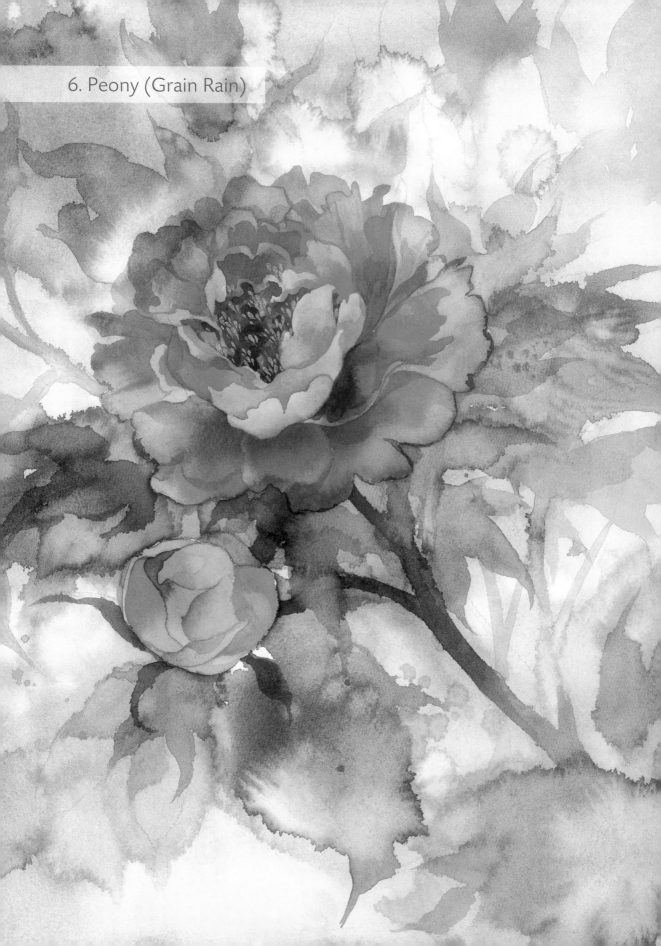

6. Peony (Grain Rain)

Grain Rain is from April 19 to 21 every year. As the last solar term in spring, Grain Rain brings about rising temperatures and plentiful rainfall, which is beneficial to the growth of grain crops.

The peony is gorgeous and magnificent in color, and is often called the king of flowers. As the flower comes in a multitude of colors, the peony is categorized into hundreds of strains, with yellow and green flowers being especially rare. Large and fragrant, the peony flower is known as "a natural beauty of the world." The peony is a symbol of fortune and nobility in China. At the end of the Qing dynasty, it was crowned as the national flower of China. There have been countless poems, articles, and paintings about the peony since ancient times (sketch on page 123).

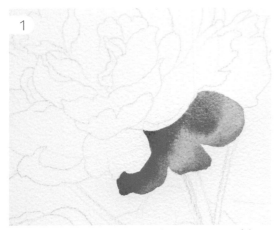

As this picture intends to weaken the presentation of the sketch, yellow water-soluble pencil is used to draw it. Draw the peony petals in bright red mixed with cadmium red, add a little rose red near the edge of the petals, then dye them in red at the edge to create a three-dimensional effect for the petals.

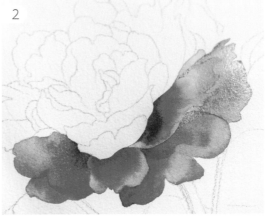

Continue to draw the petals in sequence. Remember that the closer to the flower core, the thicker and darker the color is. First use the thickest red to draw the root of the petal, then use another water brush to color the edge of the petal. You can add a little rose red near the edge of each petal.

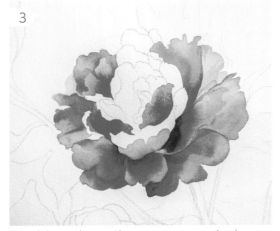

Extend the petals upward, paying attention to the change of shade. The color of the petals in the center darkens, being drawn in a mix of red, crimson, and cadmium yellow.

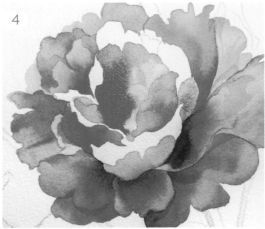

Draw the top petal edge by adding ultramarine, which will greatly enrich the color of the flower.

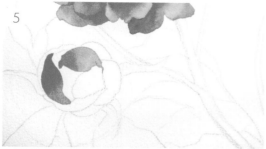

5

When waiting for the big flower to dry, draw the peony bracts at the bottom left. The color can be relatively simple. Draw in cadmium red with a little bright red.

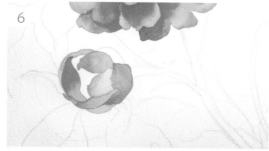

6

Add a little purple to the bracts near the core.

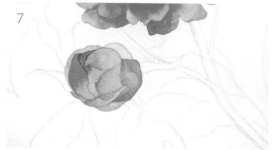

7

As the petals at the edge of the bud are not fully grown, they can be drawn in light green and lemon yellow.

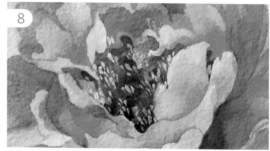

8

When the flower is partially dried, use a No. 2 sable brush dipped in gold to draw the stamens, carefully painting them to fill the center of the flower.

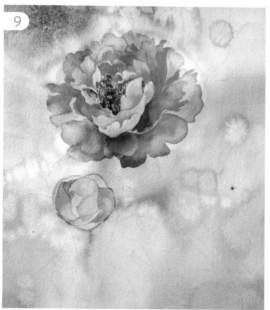

9

Use a No. 2 squirrel brush dipped in the mix of turquoise green and phthalo blue to cover the background. There should be plenty of water in the brush so that the color will not be too dark. Then, when the background is 70% dry, drop light red and light yellow to make water marks, using yellow water marks to present the leaves and red water marks to present the hazy flowers in the background.

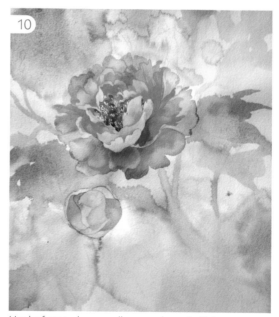

10

Use leaf green, lemon yellow, purple, and a little ultramarine to draw the leaves when the paper is nearly dry. The color of the first layer does not need to be thick so as to render the high transparency of the leaves.

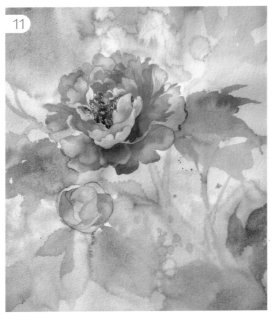

Slowly darken the color of the leaves. Use the palette to enrich the green images with different hues, then splash lemon yellow on the hazy part of the leaves at the lower part of the picture.

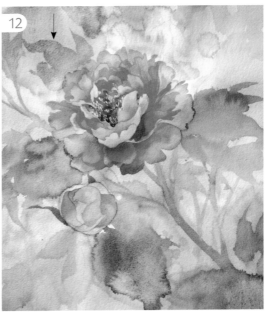

Continue to darken the leaves. When the color looks monotonous or without variation, drop water onto the leaves to create an interesting water mark effect. Blend purple with green and a litte red into a quiet gray to draw leaf in the distance (as shown by the arrow).

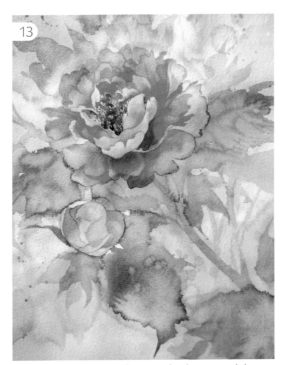

Paint all the light-colored leaves in the distance and the leaves around the small flower bud in the same gray color as in the previous step.

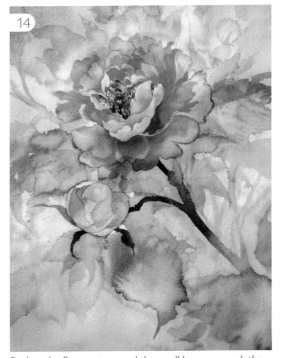

Darken the flower stems and the small leaves around the bud in dark green mixed with brown so that the leaves and the flowers are connected to the flower stem, forming an organic whole. Make sure there is variation in the thickness of the stems. The painting is complete.

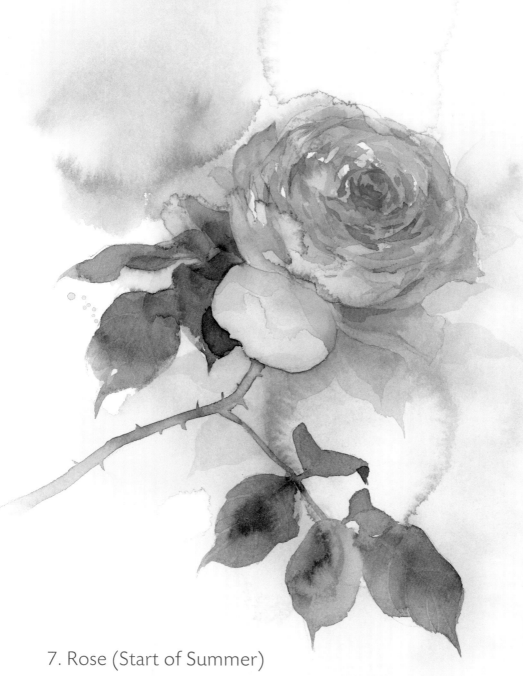

7. Rose (Start of Summer)

Start of Summer is the first solar term in summer, indicating the official beginning of summer. At this time, the summer heat will set in and thunderstorms will increase, which is an important solar period in which crops enter their peak season.

The rose has been cultivated in China for more than 2,000 years, and it has been crowned the queen of flowers. There are many varieties of the rose. There are nearly ten thousand strains in the world and more than one thousand in China. The rose is rich in color, fragrant, beautiful, and deeply loved (sketch on page 124).

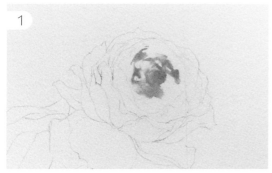

Draw the outline with pencil. Moisten the core with water, then paint it with rose red and a small amount of ultramarine blue.

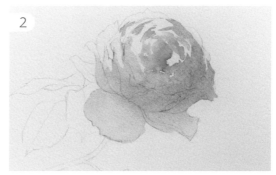

Use large strokes and clear water to create the backlight of the flowers, then mix it with ultramarine blue, rose red, orange, yellowish brown, and lake blue.

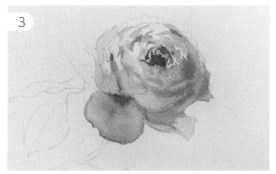

When the picture is dry, use rose red and dark red in small strokes to dry stack (see page 31) the flower core, and paint the petals around the core with diluted color.

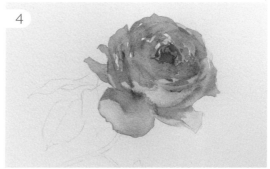

Use rose red and pink to draw the surface of the rose that faces the light.

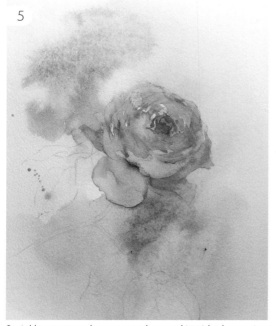

Sprinkle water on the paper and expand it with ultramarine blue, pink, and rose red.

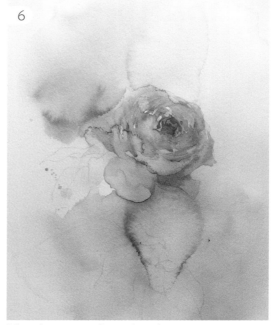

When the picture is drying, drop clear water to create appealing water marks.

7

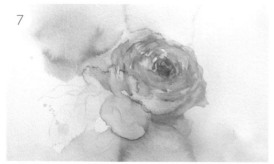

Add medium yellow to the rose red to depict the surface of the petals facing the light.

8

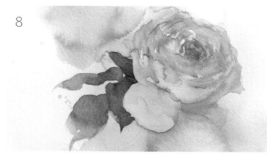

Draw the leaves with Prussian blue, Payne gray, phthalo green, and phthalo blue.

9

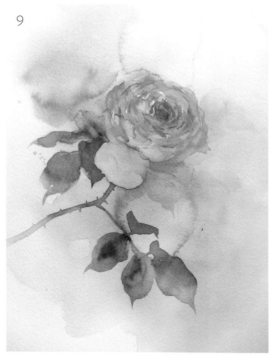

Mix sap green with a small amount of ultramarine blue and rose red, then continue to draw leaves and branches, enriching the water mark of the leaves with phthalo blue.

10

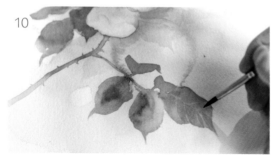

When the picture dries, continue to paint the leaves with sap green. The blank space is the vein of the leaf. It doesn't need to be exactly aligned, but should look natural.

11

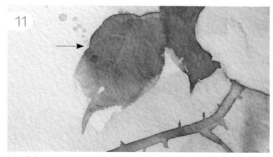

Use light sap green as the second layer of color for the leaf. Leave space where you want to show the veins (as shown by the arrow). Make sure to use light color and high transparency.

12

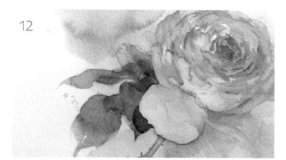

The shadow of flowers is depicted in rose red and ultramarine blue that is highly transparent. Use tree green and Prussian blue to draw the shadow and flipped part of the leaves.

13

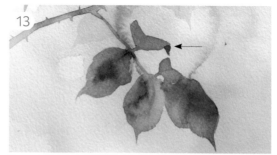

Draw the dark shadow on the back of the flipped leaf below the flower. The painting is complete.

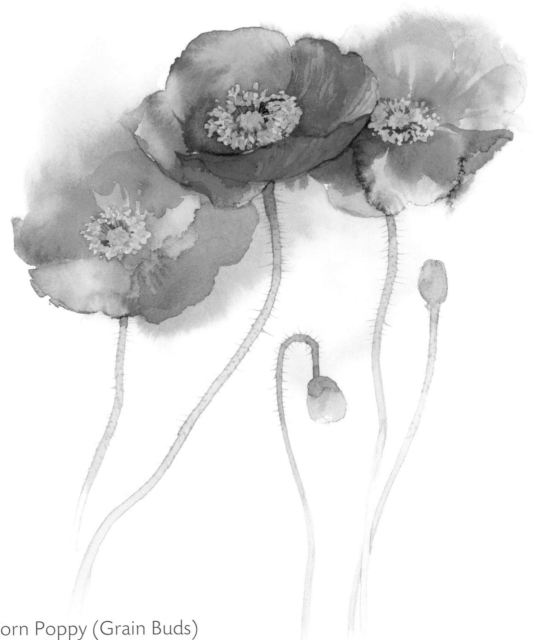

8. Corn Poppy (Grain Buds)

Grain Buds is between May 20 and 22 every year, which is also the second solar term during the summer. Grain Buds means the setting in of the rainy season with a heavy rainfall and increasing rain.

Corn Poppy (also called Beauty Yu in China) has rich colors, with thin petals that are bright and clean like silk and light corolla like crimson clouds and sky. The flower seems to waver even when there is no breeze blowing, and it looks light, as if flying, when there is wind. It is said that the flower is a personification of Yu Ji, a beauty of the Qin dynasty, so it is called Beauty Yu (sketch on page 124).

1

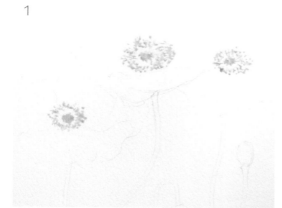

Draw the outline gently in pencil. Dot the pistils with masking fluid.

2

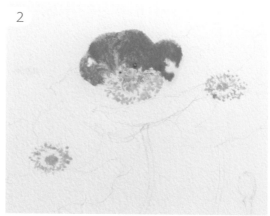

When the masking fluid is dry, the petals are first watered, then mix orange, lemon yellow, and cadmium red to draw warm red petals.

3

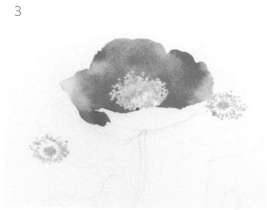

Use cadmium red and a small amount of crimson to draw the shadow of the petals, showing their turns and twists.

4

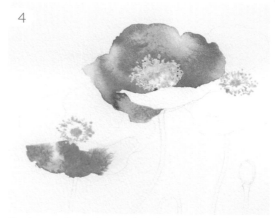

Continue to draw other petals with a wet joint technique (see page 31), the advantage of which is to highlight the beautiful water mark.

5

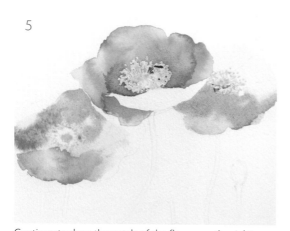

Continue to draw the petals of the flower on the right. When the petals are half dry, drop in ultramarine blue and a small amount of orange red.

6

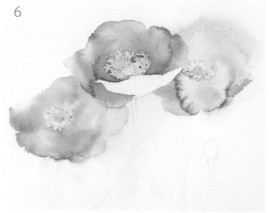

When the petals are still wet, use clear water to expand the edges of the left and right flowers, making them hazy.

7

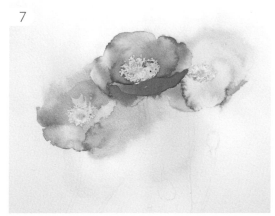

Keep distinct the main flower in the middle while dye-spreading its left and right flowers. Draw the petals under the middle flower in cadmium red and orange red.

8

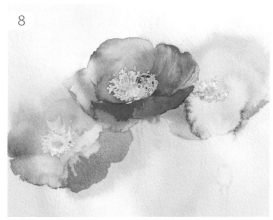

Draw the texture of the petals in dark red and cadmium yellow while they are wet. Use small strokes to enrich the texture details of the petals.

9

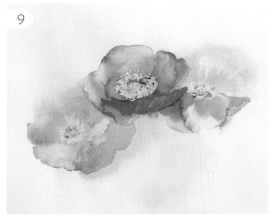

Draw the flower on the right with a mixture of bright red, rose red and a small amount of lemon yellow.

10

Add water with medium yellow and lemon yellow, draw the flower stem, and add sky blue, beginning from the middle of the flower stem.

11

Use grass green, dark green, and lemon yellow to draw other flower stems.

12

Mix turquoise into the lower two buds.

13

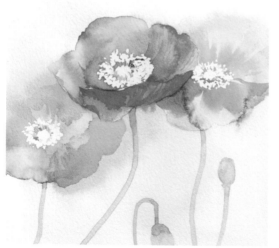

Remove the masking fluid from the pistils.

14

Use lemon yellow to paint the pistils of the left and middle flowers. Use lemon yellow and sky blue to tint the right flower's pistils.

15

Continue to add a large amount of water with lemon yellow, tinting and dyeing the pistils of the middle and left flowers.

16

Draw clear pistils with medium yellow and cadmium yellow, with the color of pistils in the middle flower being stronger.

17

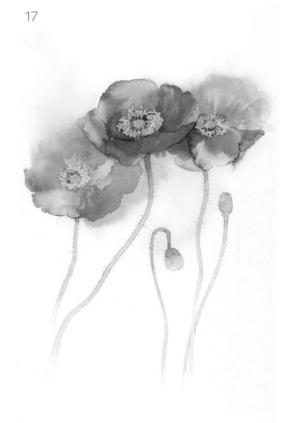

The painting is complete.

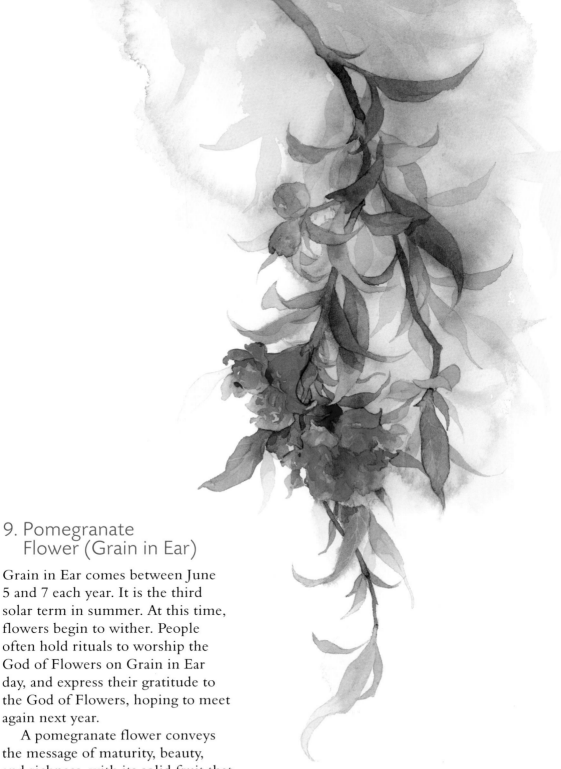

9. Pomegranate Flower (Grain in Ear)

Grain in Ear comes between June 5 and 7 each year. It is the third solar term in summer. At this time, flowers begin to wither. People often hold rituals to worship the God of Flowers on Grain in Ear day, and express their gratitude to the God of Flowers, hoping to meet again next year.

A pomegranate flower conveys the message of maturity, beauty, and richness, with its solid fruit that is full of seeds. It also has the auspicious meaning of a life full of children and grandchildren. Pomegranate flowers in the picture are in full bloom, like warm sparks. Red flowers, green leaves, and drooping branches make a refreshing, quiet summer (sketch on page 125).

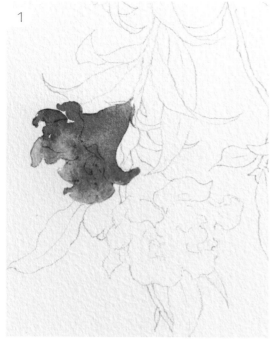

1

Draw the outline with a pencil. Wet part of the paper first, then draw pomegranate petals with red and a little medium yellow and orange red. Let the color mix naturally in the wet area, remembering to paint lightly for the first round.

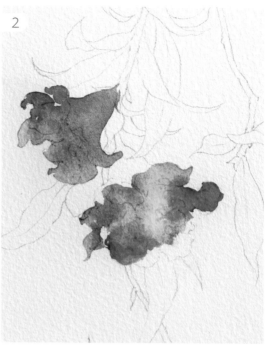

2

Continue to draw the pomegranate petals below. You can add a little lemon yellow to the previous mixed color.

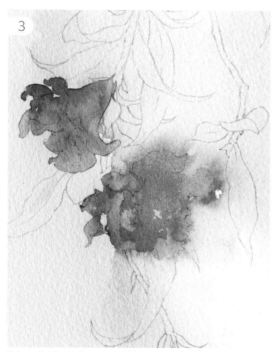

3

When finishing the second flower, wet the paper with a brush full of clear water. It does not matter that the color seeps from the edge of the sketch, as that will make it more interesting.

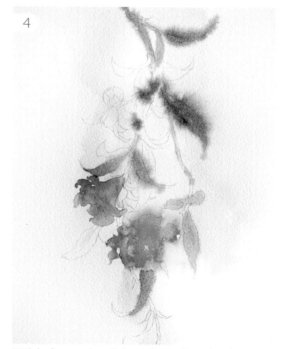

4

With leaf green plus a little medium yellow, draw hazy pomegranate leaves with the wet-on-wet technique (see page 31). Draw the flower branch with the same color.

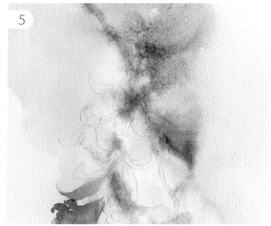

5

Mix water with leaf green and a little sky blue, color the upper part of the picture.

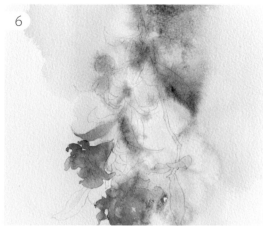

6

When the water on the paper is half dry, draw the flower buds lightly with a little cadmium red. When the paper is about to dry, drop water to make interesting water marks.

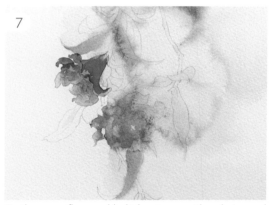

7

On the upper flower, add a little crimson with cadmium red to draw the shadow of pomegranate petals.

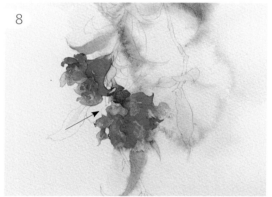

8

On the lower flower, you can use cadmium red and medium yellow to add shades to the petals. Mix in a small amount of brown to paint the root of the lower flower (as shown by the arrow).

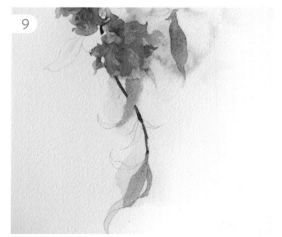

9

Draw the branches and leaves below with Payne gray and brown.

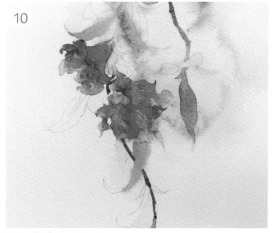

10

Draw the leaves in green.

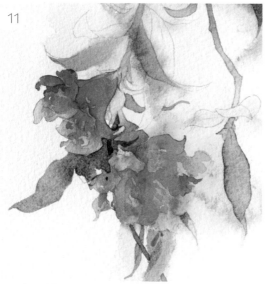

11

Mix the golden ochre with a little sky blue to make a warm green color to paint the leaves between the two flowers.

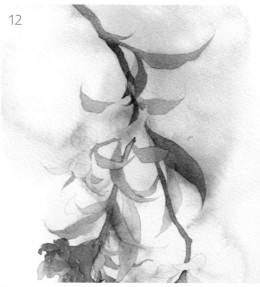

12

Use turquoise, yellowish brown, and leaf green to enrich the color of leaves.

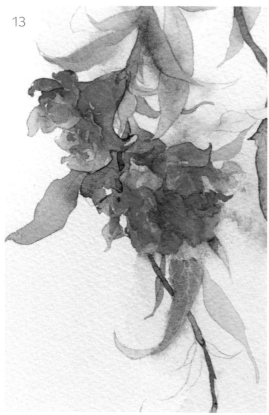

13

Draw the details of the leaves and carefully set aside the veins.

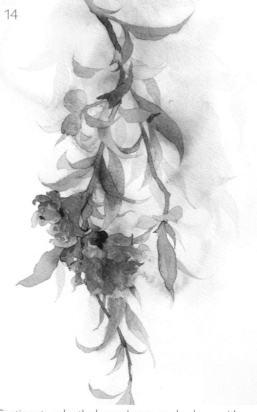

14

Continue to color the leaves. Leaves can be drawn with a slightly higher saturation of phthalo green. After painting the leaves, use clear water to extend the color on the leaves to the background when they are fast drying. The painting is complete.

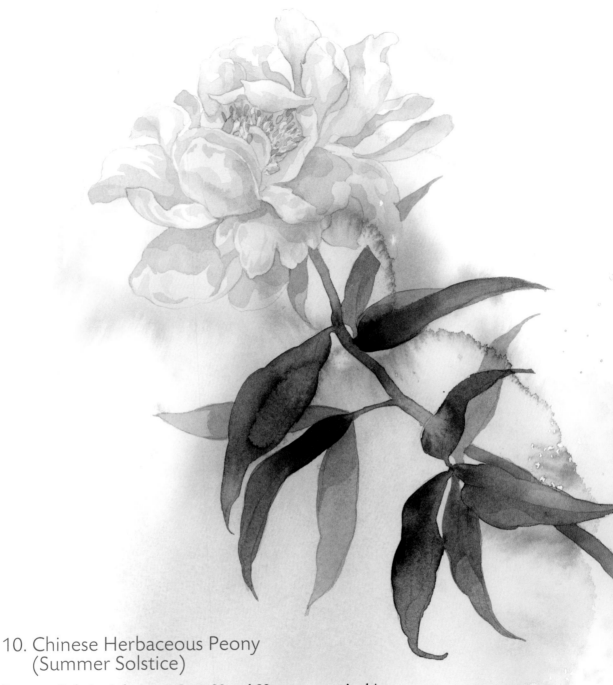

10. Chinese Herbaceous Peony
(Summer Solstice)

Summer Solstice is between June 20 and 22 every year. At this time, the daylight hours in all parts of the northern hemisphere are the longest of the year. Thunderstorms often form in Summer Solstice from afternoon to evening. They come and go quickly, and the rain only falls on small areas. Liu Yuxi (772–842), a poet of the Tang dynasty, skilfully used this kind of weather as a metaphor for his well-known verse that reads, "There is sunlight in the east and rain in the west; there seems to be no sunshine, but actually there is."

The herbaceous peony is one of the ten renowned flowers in China. An ancient Chinese comment says that the peony is the best, and the herbaceous peony is second best, and the peony is the king of flowers and the herbaceous peony the prime minister of flowers. Because it blooms later, it is also called *dian chun* (end of spring). There have been numerous Chinese poems and paintings that used the herbaceous peony as their theme since ancient times. For example, *Herbaceous Peony* painted by Zhu Da (1624 or 1626–1705), a prestigious painter in the Qing dynasty, shows the shape of the herbaceous peony in a few strokes, which is impressively distinctive (sketch on page 125).

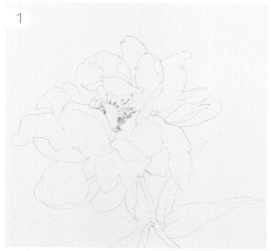

Gently outline the sketch with pencil. Dot the stamens with masking fluid.

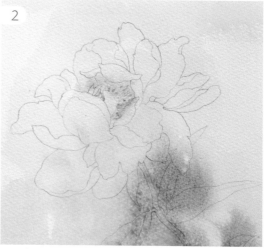

Wet the paper with water, then render the background with turquoise and leaf green. Use Indian yellow and medium yellow for the stamens.

Draw the leaves when laying the color backdrop.

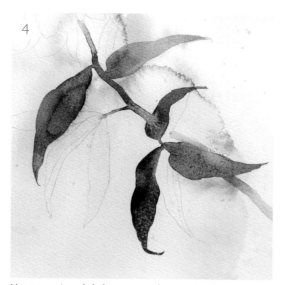

Use turquoise, phthalo green, and raw umber to draw the branches and leaves. The color of the root of the leaves should be darker than that of the tip.

5

Remove the masking fluid from the stamen part and continue to use lemon yellow and medium yellow to highlight it. Draw the petals on lower right with light lemon yellow, then add light gray to the petals.

6

Use purple, lemon yellow, and leaf green to mix a kind of purplish gray. Adding water, draw the petals lightly. The color should be light with high transparency.

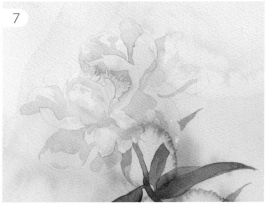

7

On the foundation of purplish gray, add ultramarine blue to form a bluish gray, then continue to draw petals. Add light yellow to the root of the petals, presenting the light while enriching the color.

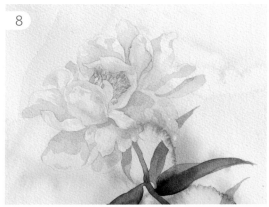

8

Use blueish or purplish gray to enrich the petal color. Mix a small amount of orange red with dark yellow to dot the stamens.

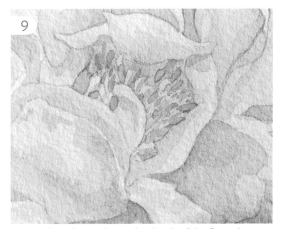

9

Use small strokes to depict the details of the flipped parts and the shadow of the petals around the stamens.

10

Use ultramarine blue and a small amount of Prussian blue to depict the leaves with high transparency. The painting is complete.

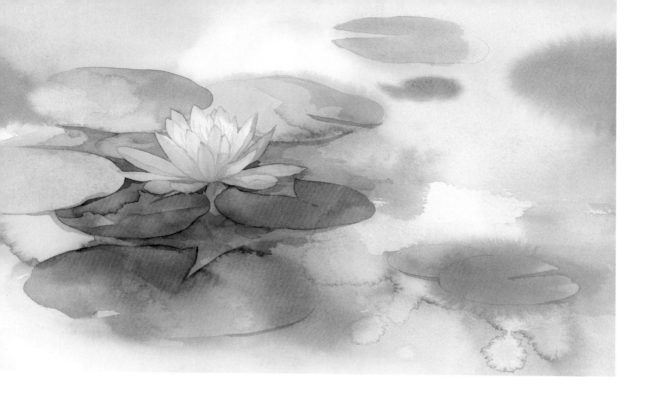

11. Water Lily (Minor Heat)

Minor Heat is from July 6 to 8 every year. It refers to mild heat, suggesting that the weather starts to turn hot, but is not yet at its hottest.

Water lilies blossom in the day and close at night, and have been viewed as the embodiment of holiness and beauty since ancient times. They are also a symbol of Buddhism. Ancient people regarded the lotus and the water lily as the same kind of flower, and they loved the noble character of both flowers because they grow "out of the mud but are not tainted." For this reason, the ancients planted many of these flowers in classical gardens to express the noble moral integrity and desire of the masters of the gardens (sketch on page 126).

1

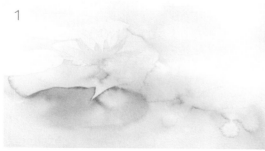

Use pencil to outline the shape and leaves of the flower, spreading water generously on the paper, then use sky blue, light purple, and a small amount of rose red to render the background and draw the outermost petals of water lily. The lower water lily leaf is drawn with yellowish brown and orange red mixed with plenty of water.

2

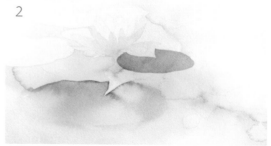

Draw the leaf near the flower with yellowish brown and orange red.

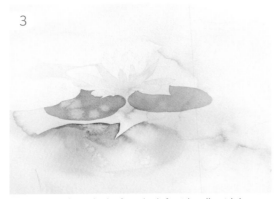

3

Continue to draw the leaf on the left with yellowish brown, adding orange red and a small amount of rose red near the flower and dropping clear water on the leaf to create a water mark effect.

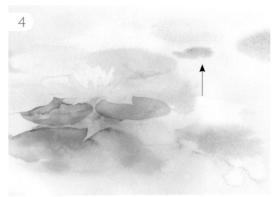

4

Wet the paper with clear water and draw the leaves and water surface with a large amount of turquoise. When the picture is half dry, mix a small amount of blue with brown to draw the small leaf on the top right (as shown by the arrow).

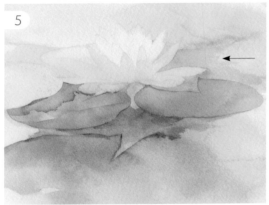

5

Use the light turquoise color to draw the shadow of the leaves hidden below (as shown by the arrow). Draw the reflection of water lily near the water surface with ultramarine blue and rose red.

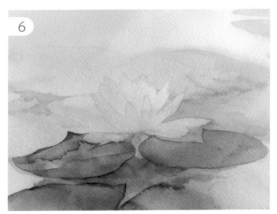

6

Use lemon yellow and turquoise to lightly draw the flower core of the water lily.

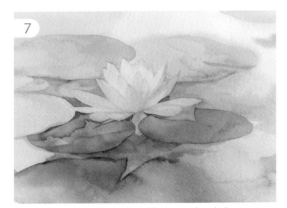

7

Continue to draw the petals with rose red and ultramarine blue. Use ultramarine blue, rose red, grass green, and turquoise, mixing it into a kind of bluish gray, then use clear strokes to draw several leaves on the left and top of the water lily.

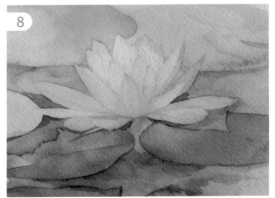

8

After diluting the medium yellow, draw the pistils. Adjust the layout and add details. The painting is complete.

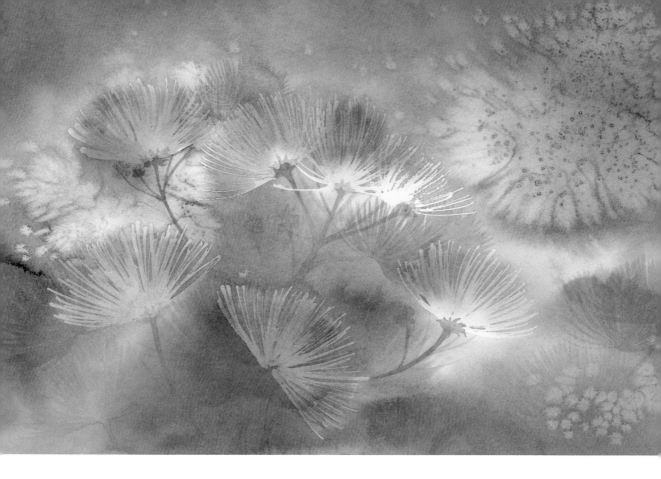

12. Albizia Flower (Major Heat)

Major Heat, from July 22 to 24 every year, is the hottest period of the year.

Albizia flowers are auspicious flowers in China. Since ancient times, there has been a custom of planting albizia trees beside the garden of the house, suggesting harmony between husband and wife, unity in the family, and goodwill and friendliness between neighbors (sketch on page 126).

Draw the flower stems with pencil and draw the radiated flowers with masking fluid.

When the masking fluid is dry, wet the paper with water and dye the background with leaf green, tree green, and turquoise. Use turquoise and a small amount of lemon yellow to draw the flower stems.

While the paper is wet, use a brush and clear water to flick water drops against the background to enrich the texture of the picture. Then use rose red to dye the flowers.

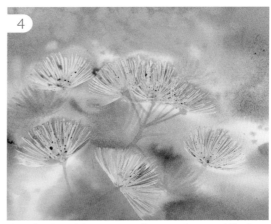

Use a brush with less water and more color to quickly draw hazy albizia flowers with the wet-on-wet painting technique (see page 31).

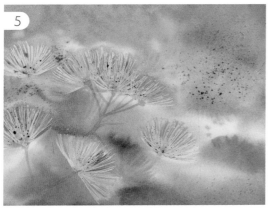

Sprinkle salt in the blank space of the picture.

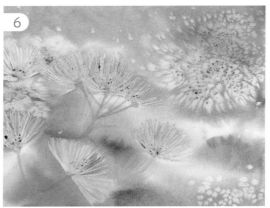

After the salted part is completely dried, clean the remaining salt particles from the drawing paper by hand. The rich texture after drying represents the distant albizia flowers.

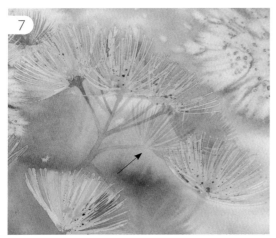

Mix rose red with a small amount of ultramarine blue to draw the light radial flower of the albizia.

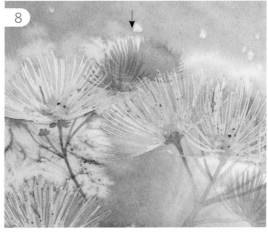

Add a small amount of rose red with ultramarine blue to draw flowers in the distance.

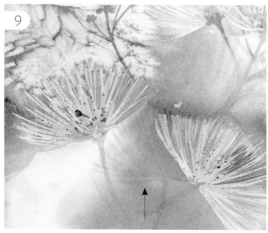

9

Use a brush with a generous amount of water to draw transparent flowers (as shown by the arrow).

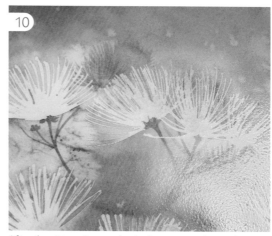

10

After the picture is completely dry, remove the masking fluid and brush a layer of clear water over it.

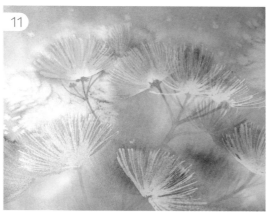

11

When the picture is a little bit dry, add rose red to the blank part of the flowers.

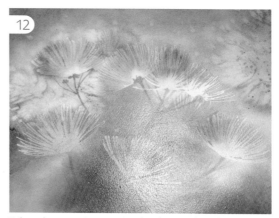

12

When the paper is not quite dry, that is, when the paper can reflect light but still retain the texture of the paper, adjust the thickness in the color of the flowers. At this time, there will appear a beautiful infiltration of the painted colors, but it will not be difficult to control.

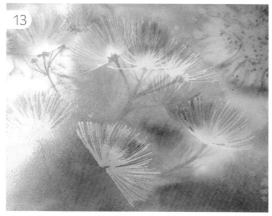

13

Use turquoise to enrich the color and background of the flowers.

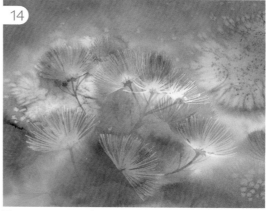

14

The picture is complete.

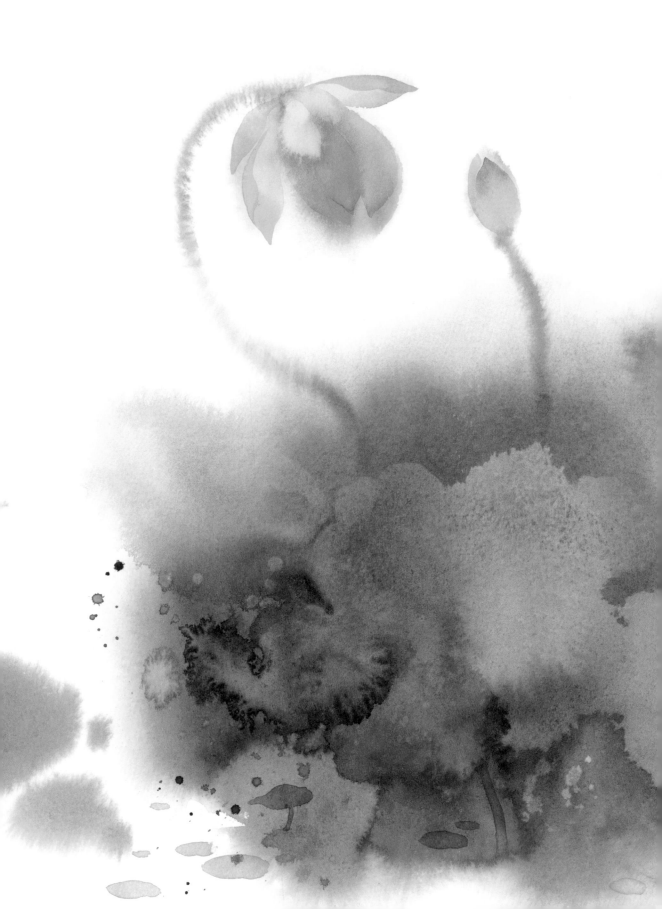

13. Lotus (Start of Autumn)

Start of Autumn is between August 7 and 9 every year. It is the starting point of autumn and the turning point of the year. Everything begins to grow from prosperity to maturity.

Yang Wanli (1127–1206), a renowned poet of the Southern Song dynasty (1127–1279), wrote that "the boundless lotus leaves are exceptionally green and the flowers are particularly red against the backdrop of the sun," which is a true portrayal of the beauty of the lotus. Like the water lily, the lotus has always been one of the subjects of traditional Chinese paintings and poems for poets and other men of letters because of its noble moral character. In addition, different parts of the lotus have therapeutic value. Lotus seeds, leaves, and stems are commonly used in Chinese herbal medicines (sketch on page 127).

1

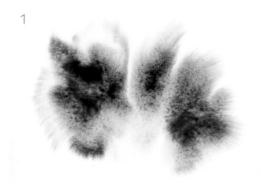

This time, we choose wood pulp paper to create a new effect. Mix grass green, burnt umber, and phthalo blue. First draw the leaves with rich colors on moist paper. You can dip in the mix of pigments and draw directly on the paper. The rich colors will naturally blend.

2

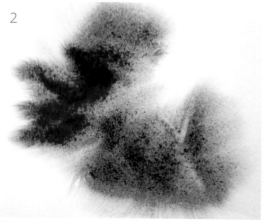

The pigment spreads quickly on the wood pulp paper. Control the direction of pigment flow by tilting the drawing board.

3

When the painting is 70% dry, mix burnt umber and ultramarine blue and draw the stems with a slightly thick color. Draw the flower bud with a little light red.

4

Draw the shape of the lotus flower with a slightly thicker red color. The flower tip is thicker in color. The other parts are extended with a watercolor brush.

5

Slowly darken the main petals. When the petals are drying, dip the brush in water and wash out the remaining petals. It is very convenient to use the water-washing technique on wood pulp paper. Water washing involves washing off the color when the paint is drying with a brush containing little water.

6

Draw the lotus leaves with turquoise, grass green, and permanent green.

7

While painting, drop in water to make beautiful water marks. Spray light ultramarine purple, blue, and green around the lotus leaves.

8

Continue to deepen the color of the lotus leaves.

9

When the lotus leaves are drying, wash out the beautiful shape of the leaves after brushing them with clear water and big strokes.

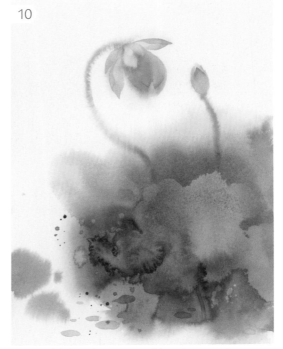

10

Draw with light color some small lotus leaves at the bottom. Enrich the details of the flower petals and the bud with light red. The painting is complete.

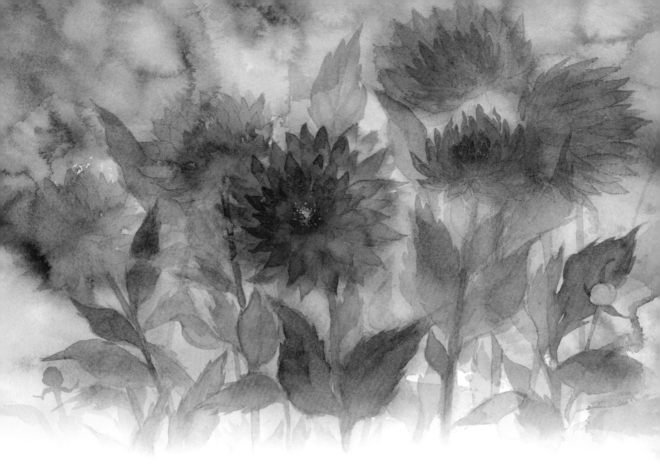

14. Dahlia (End of Heat)

End of Heat is from August 22 to 24 every year. It indicates the end of hot summer heat and reminds people that autumn is coming quietly.

The dahlia is one of the most diverse species of flowers in the world. It comes in a variety of colors and shapes. Its petals are arranged in a very neat way, unlike the peony. The dahlia is naturally unrestrained and romantic, and its flower represents auspice (sketch on page 127).

Start with a pencil and gently circle the position of each flower.

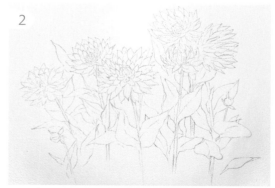

Draw the outline on the paper with pencil.

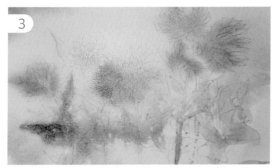

Wet the entire paper with water and boldly blend all the colors you need.

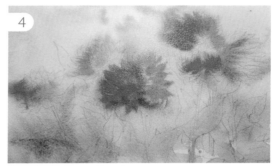

Color the flowers with red.

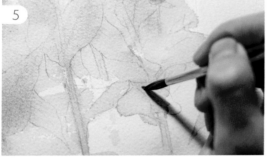

For the leaves, use the color close to that mixed in the third step to enrich the details.

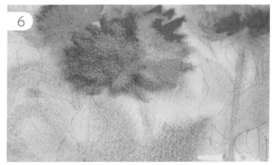

When the pigment is half dry, drop water into the flower to create water mark effect.

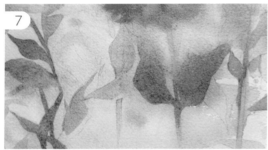

The leaves in the center of the picture are bright green, and the leaves around them are quiet green, creating a sense of variation.

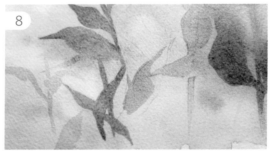

Pay attention to the change in the color of the leaves. The edge of the leaves can be expanded with a brush dipped in water.

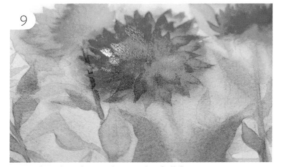

Use rich red to depict the petals of all flowers.

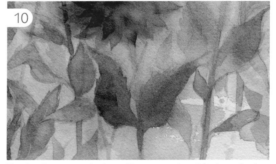

Depict the serrated edge of leaves, and enrich the color in the middle of leaves with similar colors.

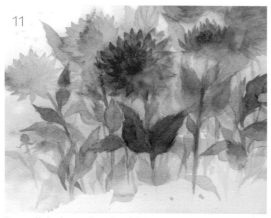

Draw all the leaves in color rich in water content. Note that the color of the leaves near the front should be rich and deep, and the color of the leaves behind should be light, so that there is a distinction between the front and the back and variation between the solid and the vague.

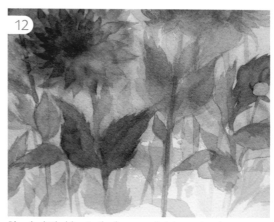

Blend a little blue in the leaves to brighten the picture.

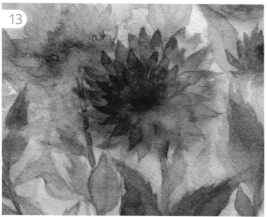

The red of the flowers also has variations in brightness, and the lower part the flower will be more towards rose magenta.

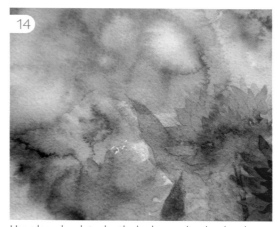

Use a large brush to dye the background and make a hazy picture.

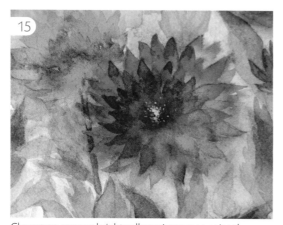

Choose an opaque bright yellow pigment to paint the stamens.

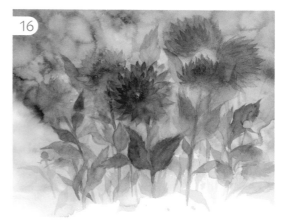

The painting is complete.

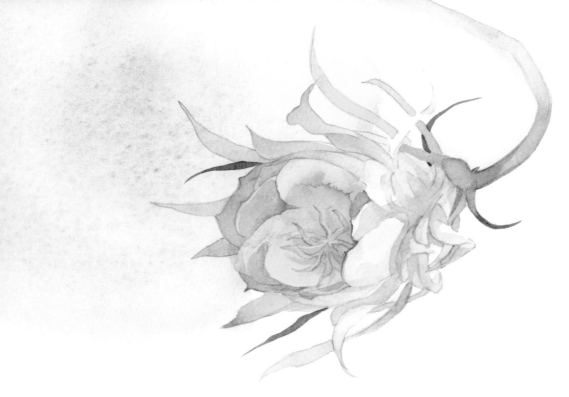

15. Epiphyllum (White Dew)

White Dew is between September 7 and 9 every year. It is an important solar term reflecting the change of temperature in nature. It is a turning point from sultry to cool weather in autumn.

The epiphyllum is a noted ornamental flower, commonly known as "beauty under the moon." During the summer and autumn solar terms, when the stars are scattered across the sky late at night, the epiphyllum quietly blossoms to show its beautiful elegance. When people are still asleep, the simple fragrant epiphyllum closes and withers, leading to the expression "a glimpse of epiphyllum." In China, people use this term to describe the transience of good things. The epiphyllum stands for transient beauty, a moment of eternity (sketch on page 128).

1

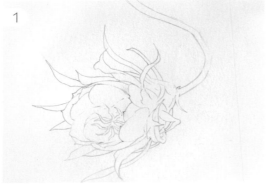

After sketching in pencil, roll a kneaded eraser over the surface to lighten the sketch.

2

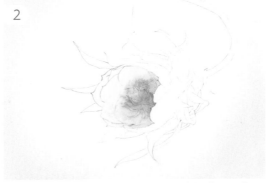

Add a strong yellow color to the center of the flower, then use the brush to spread it.

3

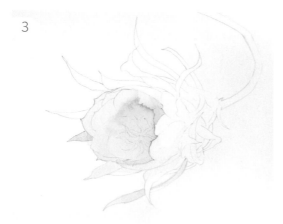

Use layers of quiet colors to dye around the core, forming a contrast with the bright color in the center.

4

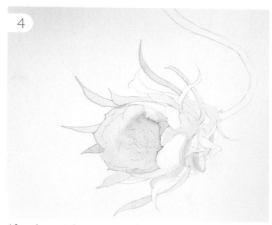

After the periphery is painted with quiet colors, the long, thin petals on the right side of the flower are painted with warm colors, making the core more prominent.

5

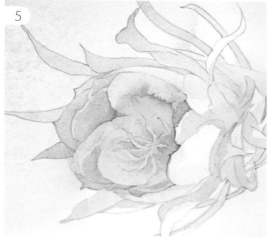

Use warm colors to enrich the layering of the flower's core.

6

Draw the flower pole in light green.

7

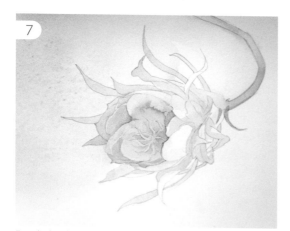

Enrich the details of the surrounding petals with the corresponding colors. Tint the background with a light ultramarine blue on the left side of the flower.

8

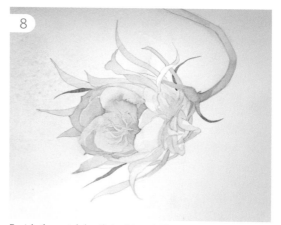

Enrich the petal details in rich red. The painting is complete.

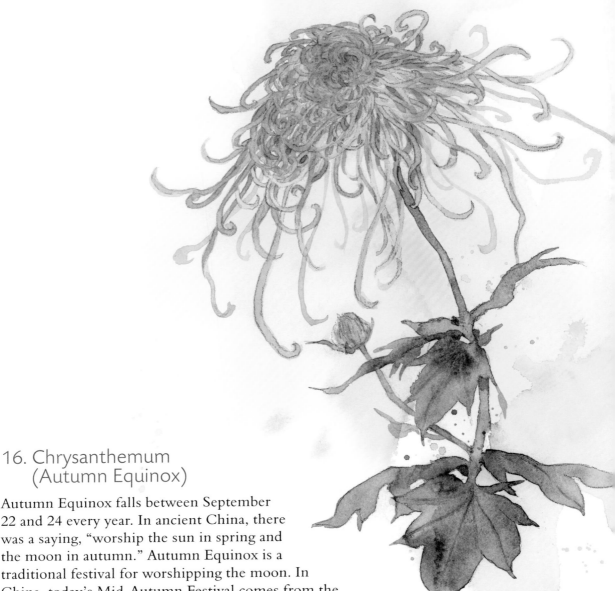

16. Chrysanthemum (Autumn Equinox)

Autumn Equinox falls between September 22 and 24 every year. In ancient China, there was a saying, "worship the sun in spring and the moon in autumn." Autumn Equinox is a traditional festival for worshipping the moon. In China, today's Mid-Autumn Festival comes from the traditional festival for worshiping the moon.

The chrysanthemum is one of the ten famous flowers of China. It is also considered one of the four elegant gentlemen (the other three are plum blossom, orchid, and bamboo) because of its pure, elegant character, that does not seek to compete with other flowers. A popular saying is, "Picking chrysanthemum under the eastern fence and leisurely viewing Nanshan Mountain," a line penned by the famous poet Tao Yuanming (365 or 372 or 376–427). Chinese people also enjoy the chrysanthemum and drink chrysanthemum wine on the traditional Double Ninth Festival. In ancient Chinese myths and legends, the chrysanthemum stands for auspiciousness and longevity (sketch on page 128).

1

Sketch the chrysanthemum with pencil. Starting from the center of the chrysanthemum, dye it with yellow.

2

Mix orange red with yellow. Draw the petals around the center carefully.

3

Blend a little purple into the yellow color to depict the lower petals. The shadowed parts of the petals interspersed with each other are also drawn with a deeper yellow color.

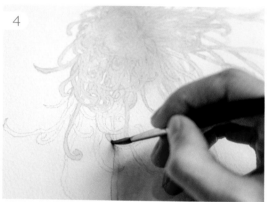

4

Continue to draw the petals below with transparent orange red.

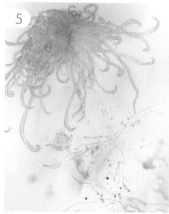

5

Use a large brush to spread yellow as the background, splashing yellow and purple color spots.

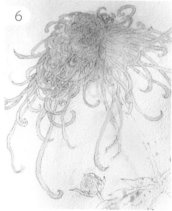

6

Add layers of transparent fuchsia and orange red to the petals.

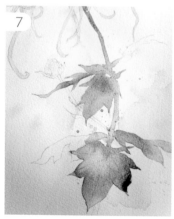

7

Draw chrysanthemum leaves and stalk. The upper part of the leaves is brighter and the lower part is quieter in color. Make sure there is a distinction between them. Make water marks on the lower leaves.

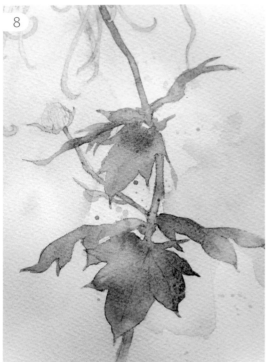

8

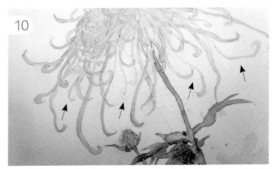

9

Draw the middle part of the chrysanthemum in orange red.

10

Continue to add leaves. Gradually deepen the color of the leaves and stalks.

Enrich the details of the petals and lightly draw the petals in the distance. Draw the bud in orange.

11

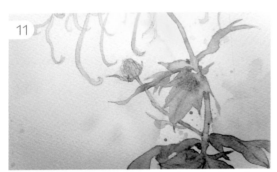

13

When the color of the leaves has dried, use bright and quiet colors to draw the veins on the corresponding leaves.

12

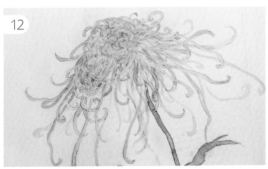

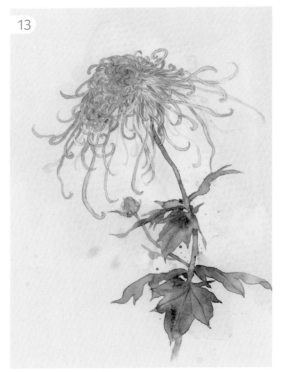

It's hard to grasp the complexity of chrysanthemum petals, so the details must be darkened with care.

The painting is complete.

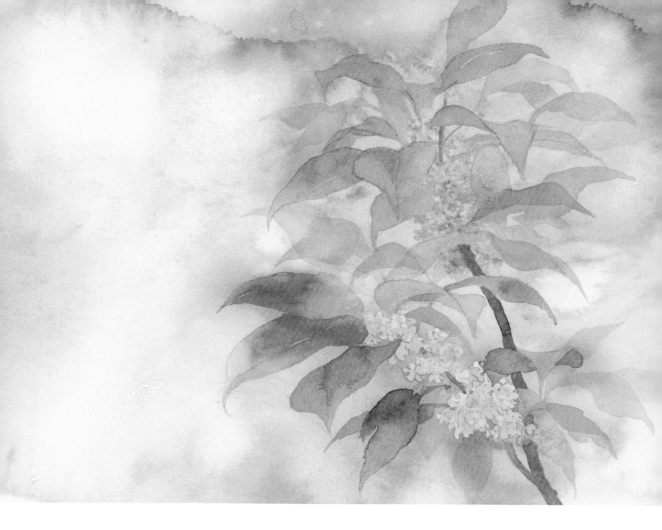

17. Sweet Osmanthus (Cold Dew)

Cold Dew is from October 7 to 9 every year. After Cold Dew, the days are shorter and the nights longer, with less sunlight and dissipated heat. The cold grows, and the temperature difference between day and night increases.

The sweet osmanthus is one of the ten famous traditional Chinese flowers. As its fragrance is exceptionally pure and fresh, strong and far-reaching, it can be regarded as a unique flower. In particular, in the mid-autumn, when sweet osmanthus is in full bloom and the night is quiet and the moon round, it is refreshing to enjoy the wine and the fragrance of the flower. The sweet osmanthus blooms in autumn, which coincides with the time of the ancient imperial examination. For this reason, people use the word "winning the sweet osmanthus laurel" to describe the number one scholar in the exam. Today, this word is still used to describe success in an official career or first place in a competition (sketch on page 129).

Use a pencil to sketch the line draft gently. There is no need to draw the flowers. Just leave them blank space.

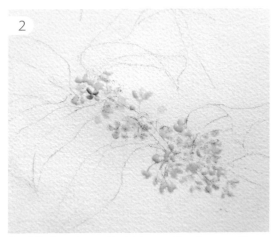

Carefully draw the small, trivial osmanthus flowers with masking fluid.

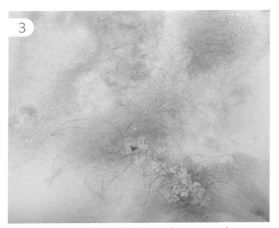

After the masking fluid is dried, wet the paper with water and dye the main part of the flower with yellow and orange red, then dye the background with bluish green.

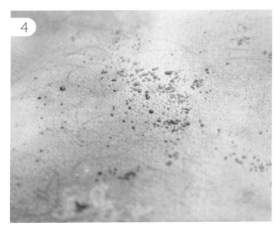

Sprinkle salt on the flowers.

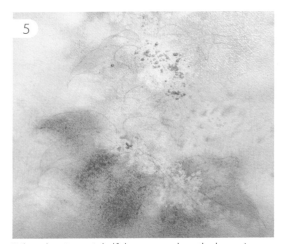

When the picture is half dry, start to draw the leaves in bright green.

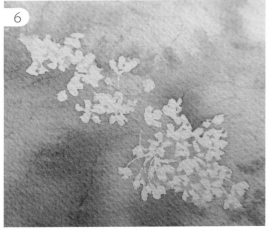

When the picture is completely dry, remove the masking fluid and salt.

Then dye the flowers with yellow. When the flowers have dried, continue to enrich the details of the small petals.

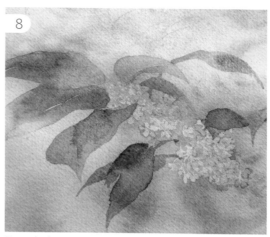

Draw the leaves in green and use a small brush to make water marks on the leaves to enrich the effect.

Be careful to depict the variation in the lightness of color at the flipped part of the leaves.

Carefully use variation in the lightness of color on the overlapping parts of the two leaves to show the shadow on the parts that are blocked.

The leaves of the upper half of the sweet osmanthus are painted with light, quiet green.

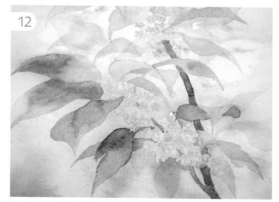

Paint the branches in ultramarine blue and burnt umber, as the dark colors present the hardness of the branches. When the pigment is not entirely dry, use small brush to drop water onto the branches to strengthen the effect. The painting is complete.

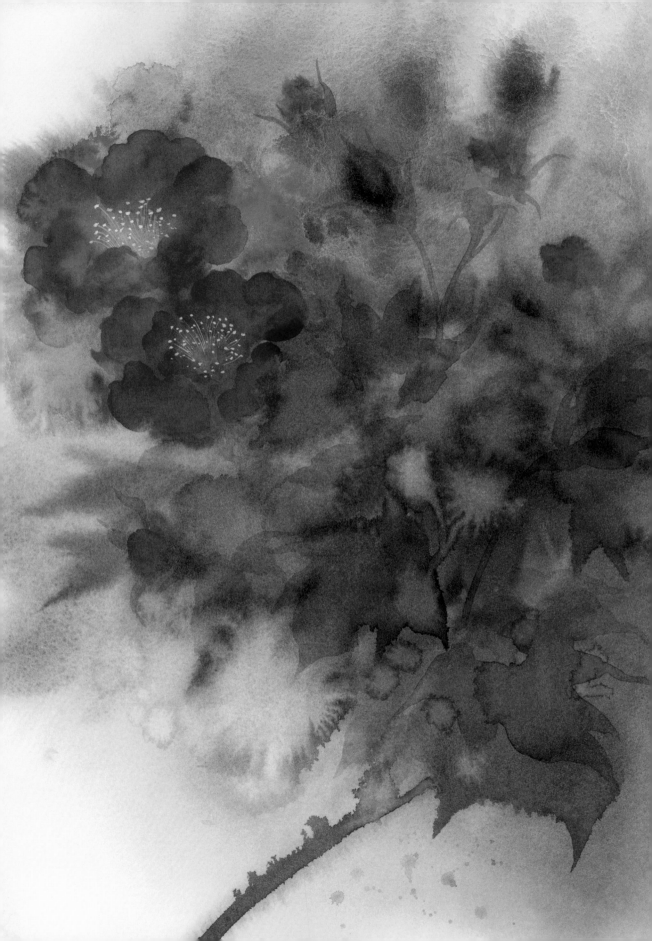

18. Cottonrose Hibiscus (Frost's Descent)

Frost's Descent is between October 23 and 24 every year. It is the last solar term in autumn, indicating the transition from autumn to winter. After Frost's Descent, the plants gradually lose their vitality and the earth is bleak.

Cottonrose hibiscus blooms in late autumn with big beautiful flowers. It has been planted in gardens since ancient times in China. Whether it is planted alone or in clusters beside walls, by roadsides, or in front of halls, it can make the whole landscape look unique. Due to the difference in the intensity of the light, the concentration of anthocyanin in the petals of the hibiscus will change, making the petals present different colors, white or light red in the morning and dark red at noon and in the afternoon, so the hibiscus is also called "thrice drunk hibiscus." The hibiscus flower is often used to describe beautiful women and the auspicious rich life in Chinese literary works. For example, Li Bai (701–762), a famous poet of the Tang dynasty, once wrote the lines, "hibiscus coming out of water naturally, with no artificial decoration," to show the refreshing beauty of the hibiscus flower and symbolize natural female beauty (sketch on page 129).

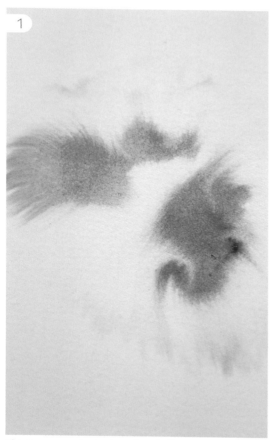

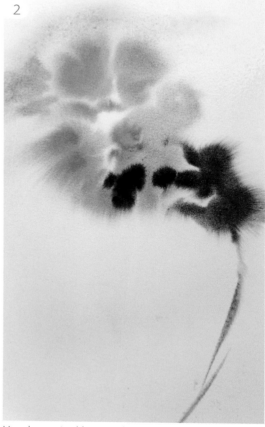

This time, use color to draw directly. First, use rose magenta to situate the flowers on wet paper.

Use ultramarine blue mixed with a little burnt umber as a strong color for situating the branches.

3

When the paint is still wet, tilt the paper to let all the colors flow and mix together naturally.

4

When the paper is more than half dry, draw the flowers with a stronger red color.

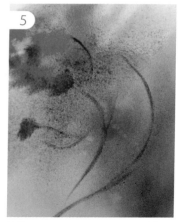

5

Using grass green, wave your wrist to move the brush quickly to draw rhythmic branches.

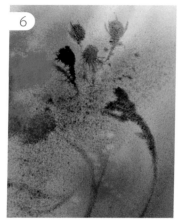

6

Draw green buds against the background.

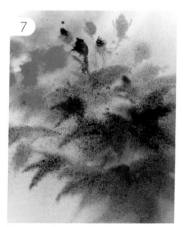

7

Draw the shape of the leaves with wet-on-wet technique (see page 31), using variations in color.

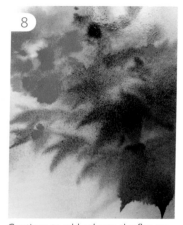

8

Continue to add color to the flowers. Intersperse the leaves with red buds.

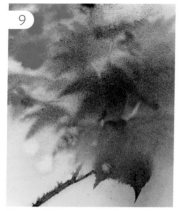

9

Use earth brown, turquoise, and leaf green to draw the branches of flowers.

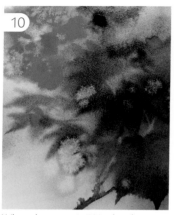

10

When the paper is 70% dry, drop water to create water mark effect.

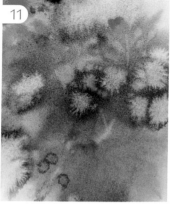

11

Use a brush dipped in turquoise blue to splash on the leaves, creating a lively atmosphere and breaking through the dull colors of the leaves.

12

Add vermilion and permanent orange red to the flower.

13

Add a little ultramarine purple to the green to draw leaves with clear edges as shown by the arrows.

14

When the picture is completely dry, draw the petals. Mix a little yellow in the center of the flower to set aside the position of the pistils.

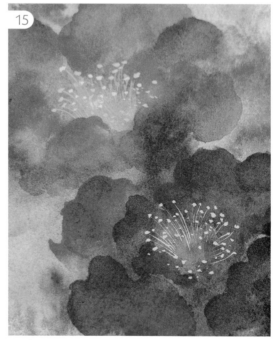

15

Finally, draw the pistils with opaque yellow. The painting is complete.

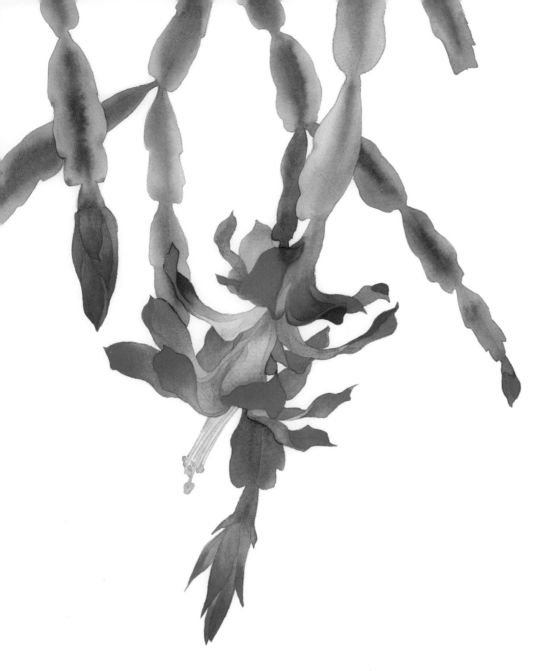

19. Crab-Claw Orchid (Start of Winter)

Start of Winter is on November 7 or 8 every year. There is a gradual shortening of the day, and everything is retreating in order to keep warm during the winter months. In ancient China, people in some places offered sacrifices, banquets, and other activities to celebrate Start of Winter as an important festival.

The crab-claw orchid is named for its shape, which is similar to the minor claws of a crab. It is commonly seen in Chinese parks and gardens. It is bright in color, warm-looking like fire, and symbolizes fortune and a smooth life (sketch on page 130).

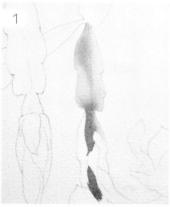

1

First wet the flower stem with water, then mix in leaf green on upper part and dark green on lower part.

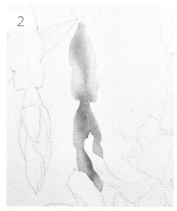

2

Draw the midline of the flower stem first, then use the mixed color to dye it on both sides so that the image will look three-dimensional, not flat.

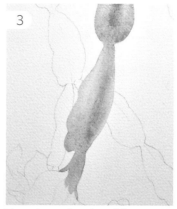

3

The color on the edge of the stem can be mixed with light turquoise.

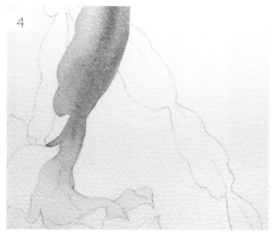

4

Using less water and more paint on the brush, go on to draw downwards with leaf green.

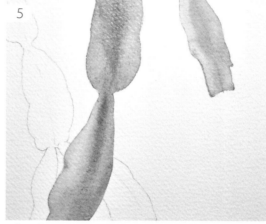

5

When the color is wet, draw the points on the zigzag edge of the flower stems with earthy red and let it seep naturally.

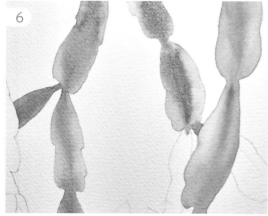

6

The color of flower stems can be painted in green with rich hues, bright or quiet, based on the actual color, or on one's own preferences for artistic expression.

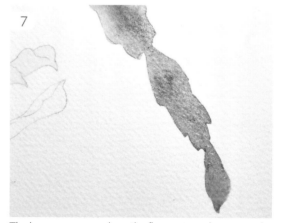

7

The lower you move along the flower stem, the more red can be mixed in with the color. The flower bud is painted entirely in red.

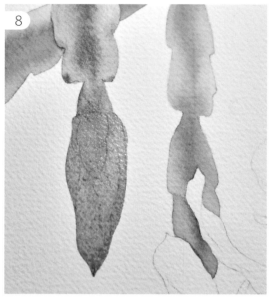

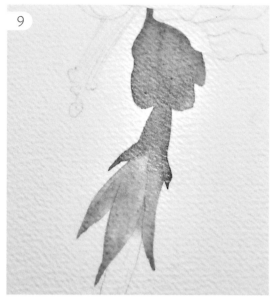

The flower bud is first drawn in red, then mixed with a little red orange to show the color change of the petals, making them appear more three-dimensional.

Other corolla parts can be painted with cadmium yellow and a little red. Note that it is unnecessary to make all the colors uniform, but rather, to present the flowers in variety.

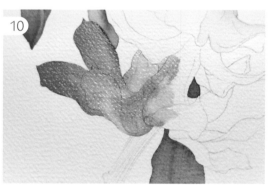

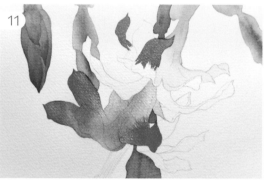

Draw the tip of the petals with cadmium red, and then use another brush with water to dye toward the root of the petals.

Then when the flower is wet, color the petal tips again with cadmium red. Other flowers can be drawn with the same color together.

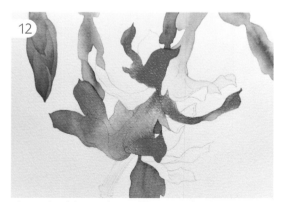

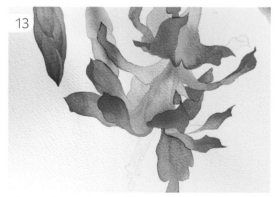

The inside of the petals can all be painted with cadmium red, and the back part can be dyed with a lighter hue.

After the flowers have all dried, use a No. 6 sable brush to draw the details on the back of the petals.

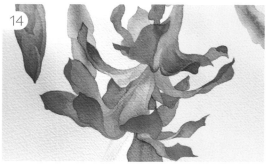

Mix cadmium red with a little dark green and draw the turning details of the petals and the petal tips.

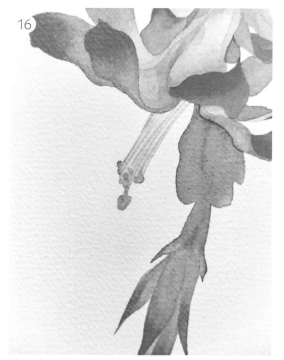

The color of the head of the pistils needs to be darkened, and the silk part of the pistils should be depicted and completed.

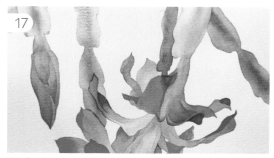

Finally, dye several flower stems with a layer of transparent turquoise. Note that we should use a color with high transparency so as not to cover the color below it.

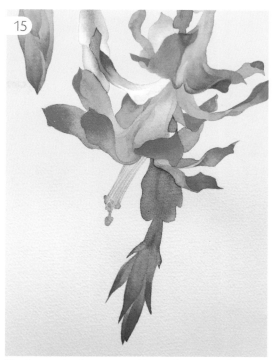

The flowers that have not yet bloomed are painted according to the same method of drawing the ones in blossom, then the pistils are painted in light red.

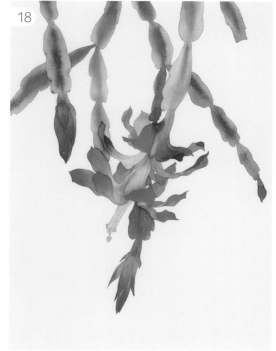

The painting is complete.

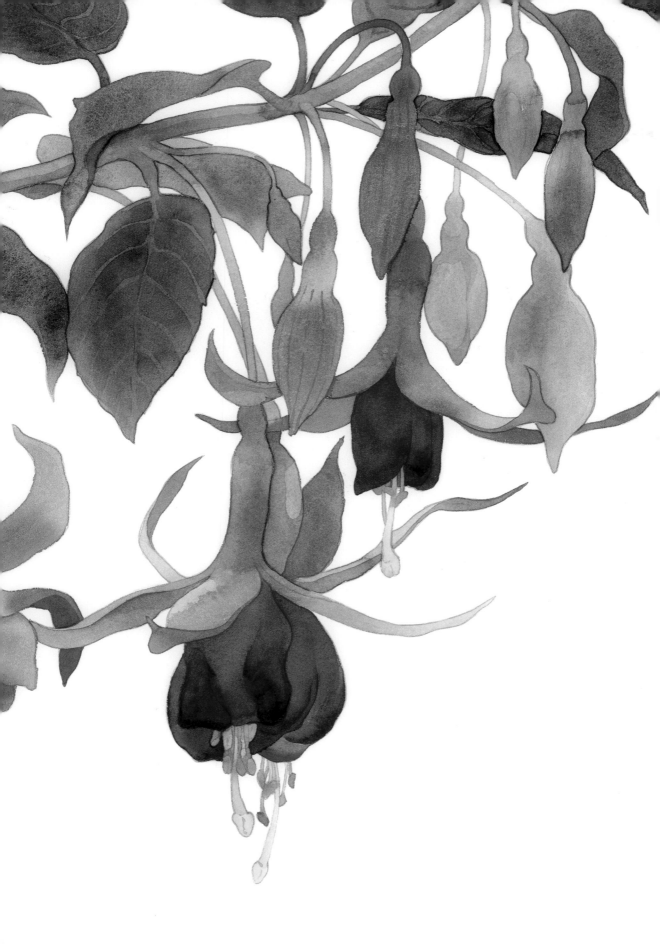

20. Chinese Enkianthus (Minor Snow)

Minor Snow is on November 22 or 23 every year, which is the solar term for frequent cold waves and strong cold air, indicating that the winter snowfall is about to start. There is a Chinese saying, "Auspicious snow means a good harvest," meaning that the snow can reduce pests, increase soil fertility, and facilitate the harvest the following year.

Chinese Enkianthus are like little bells hanging on the branches, and are also called upside-down golden bells. Since the mid Qing dynasty, there has been a custom of using Chinese Enkianthus as the flower for welcoming and decorating the new year, and it is regarded as an auspicious omen that "once the golden bell rings, a ton of gold will come." As a further auspicious sign, the Chinese Enkianthus all grow on the top of the branch, which symbolizes a high score in the imperial examination (sketch on page 130).

Use rose red, ultramarine violet, and leaf green with high water content to draw the joint part of the petals and sepals of the Chinese Enkianthus. The leaf green should be used in small amounts for ornamentation only.

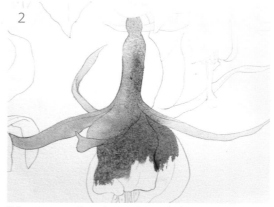

When it is wet, draw the petals in a thicker rose red and ultramarine violet.

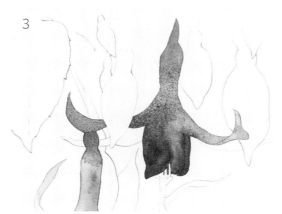

For all flowers and buds, the position of the ultramarine violet should be on the backlit side, so that the petals, with the different shades of colors, will look more three-dimensional and not too flat.

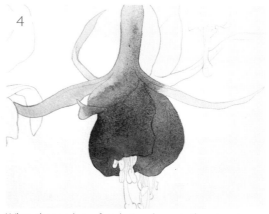

When the petals are fast drying, decorate them in crimson to darken the part of petals covered by the sepals.

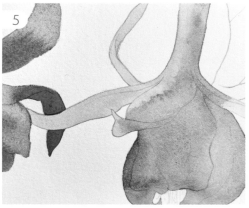

5

Continue to draw the flowers on the left in bright red. The color between the flowers should be differentiated to make the color richer.

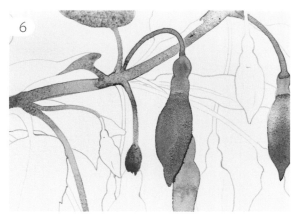

6

Draw different flower buds in rose red and bright red. The flower stem is painted with a little brown mixed with leaf green. Light red and brown should be used to draw the branch, as the color of the branch is reddish.

7

When the leaves are mixed with green and brown, add more brown to the root of the leaves, so that the color will not be abrupt when they are connected with the red branches.

8

Using ultramarine and a little rose red to draw the flowers blocked by those in front, creating spatial variation.

9

Mix bright phthalo blue with a little yellow to draw the remaining leaves other than the green and brown leaves, making the color immediately appear more vivid.

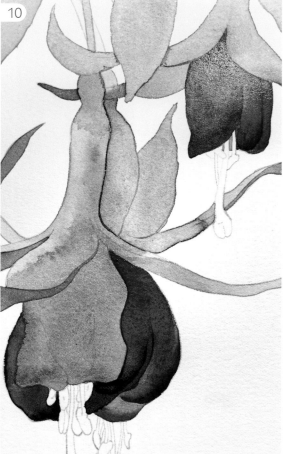

10

After the previously painted flower dries, begin to draw the second layer of color in a thicker purplish red color and a little opera pink. When coloring, remember that the part of the petals near the center of the flower is more purplish, and the more upward it becomes purplish red.

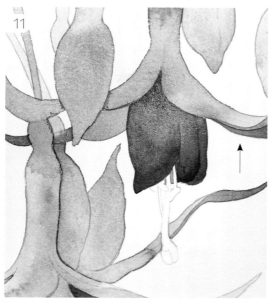

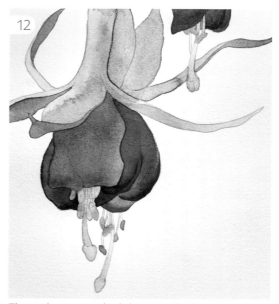

Be patient when coloring. Do not paint out of the borders. The color of the backlit calyx should be painted in light red (as shown by the arrow).

The pistils are painted in light rose and red orange, differentiated from the thick color of the petals.

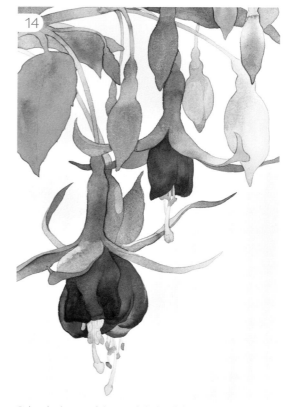

Use ultramarine violet and do not mix colors. Directly color and dye the layer of petals so that the color will turn out pure rather than blurry.

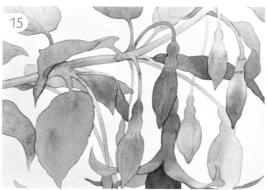

When all the colors are dry, use a No. 0 detail brush to draw the vertical line details on the flower buds and the vein details on the leaves to enrich the picture, then complete the entire picture.

Color the layers of the petals behind the largest flower, so that they do not look stiff.

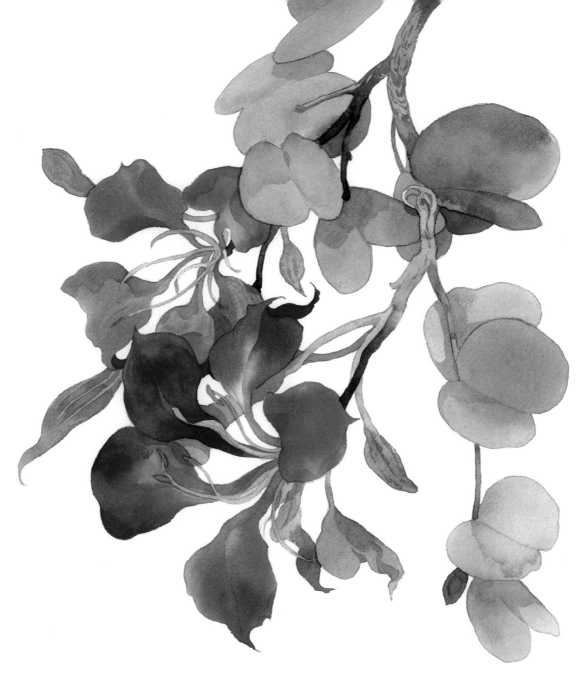

21. Bauhinia (Major Snow)

The Major Snow occurs on December 7 or 8 every year, when the weather is colder and more snow falls. In ancient times, people began to prepare for the new year around the time of the Major Snow, making it full of the festive flavor of the new year.

Bauhinia flowers are as bright as a rosy cloud, with elegant fragrance. Five independent petals, like passionate flames, emerge from the branches. They are mostly seen in southern China. They are not only popular ornamental plants, but also have medicinal value in the practice of traditional Chinese medicine (sketch on page 131).

1

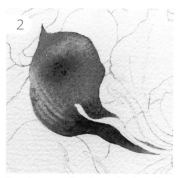

2

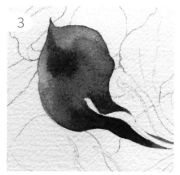

3

Draw the petals of the bauhinia in rose red and ultramarine violet.

Continue to mix crimson in the color, drawing the petals close to the core to make the turning part of the petal more prominent.

When the color is 90% dry, continue to draw the central part of the petals in dark purple red.

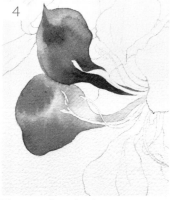

4

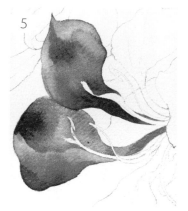

5

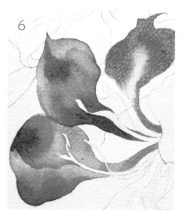

6

The second petal is drawn in rose red and light red, avoiding the midline of the petal and coloring on both sides.

Mix a little ultramarine in the lower petal. When it dries, draw the second layer in detail in bright opera pink and rose red.

Continue to draw the third petal in purple and rose red, avoiding the midline part.

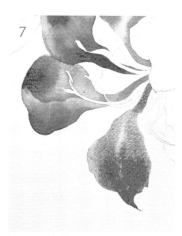

7

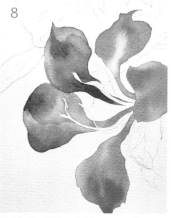

8

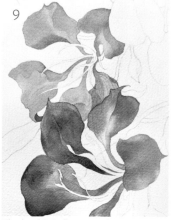

9

The petal below is drawn in rose red of different shades. Present the three-dimensional feeling of the petals in various shades of one color.

Finish the fifth petal in rose red. When drawing the petals of the bauhinia, make sure to leave blank space and avoid the pistils. You can also put masking fluid on the pistils before painting.

The bauhinia flower in the background is painted in rose red and ultramarine. The details need not be as rich as the one in the foreground.

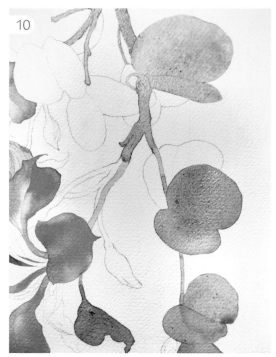

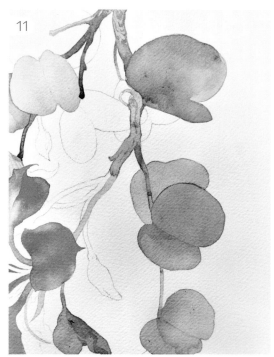

Start to draw the leaves in cerulean blue and leaf green, using brown to mix with the ultramarine for drawing the branches.

Add more leaf green in the cerulean blue to draw lighter leaves in the picture, and use the No. 4 sable brush to patiently draw the details on the branches.

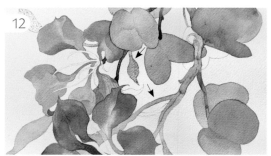

Mix a little rose red and brown with ultramarine to draw the flower stem and small flower buds as shown by the arrows. The color of the flower stem should be light.

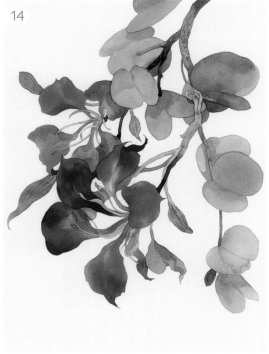

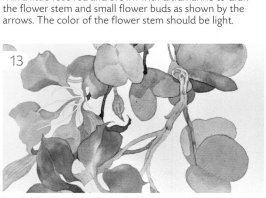

Mix leaf green with a little ultramarine to draw the shadow between the leaves. Complete the details on the flower buds and other small petals and stems.

When you have drawn the pistils in light red and orange yellow, the painting is complete.

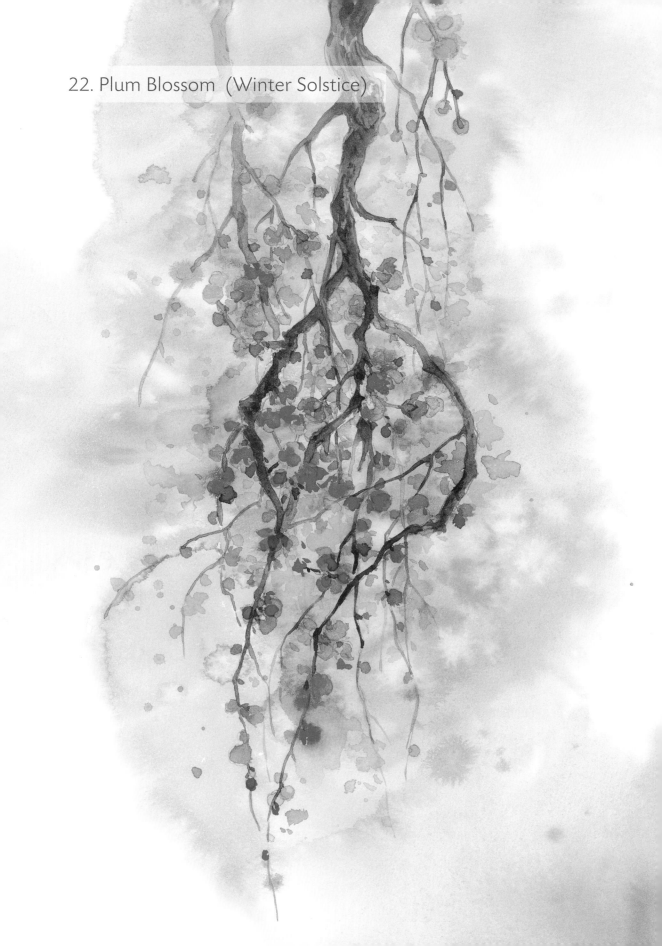

Winter Solstice is around December 22 every year. At this time, the day in the northern hemisphere is the shortest, and the more northward you go, the shorter the days become. When the Winter Solstice arrives, the plum blossom will begin to bloom, indicating the coming of spring before all the other flowers blossom. As one of the ten most famous flowers in China, the plum blossom originates in southern China, with a cultivation history of more than 3,000 years. Together with the orchid, bamboo, and chrysanthemum, it is viewed as one of the "four elegant gentlemen" flowers, and together with pine and bamboo, it is known as one of the "three friends of winter." In the traditional Chinese culture, plum blossom, with her noble, strong, modest character, inspires people to work hard (sketch on page 131).

1

Spray the paper with a watering kettle, then dip a large No. 2 squirrel hair brush into medium yellow, coral red, and a little red orange to color the backdrop, avoiding the main body of the plum blossom.

2

When the backdrop is 70% dry, use a water brush to shake up small water marks to enrich the texture of the background, and then use a No. 6 sable brush to dip in the medium yellow and dye it on the lower part of the plum blossom.

3

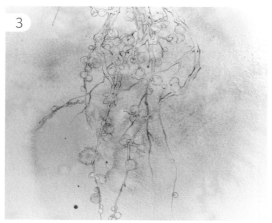

While it is wet, continue to color the flower of the plum blossom with coral red.

4

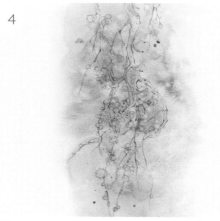

When the background color is spreading, continue to mix with light red orange to complete the uncovered parts in the background. The petals of the plum blossom are also lightly decorated with a little light rose red.

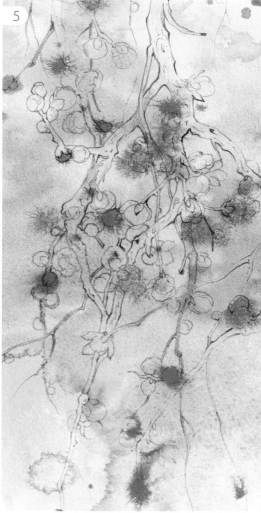

5

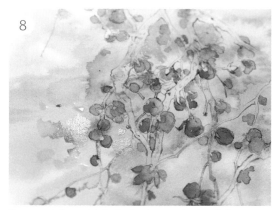

When the picture is 70% dry, roughly draw the petals in thick rose red on the sketch.

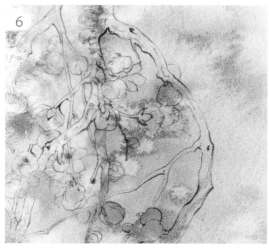

6

In step 5, the petals are painted while the paper is still wet. After drying, the beautiful water flowers shown in the picture will emerge. This kind of water mark is the beauty of my favorite watercolor paintings.

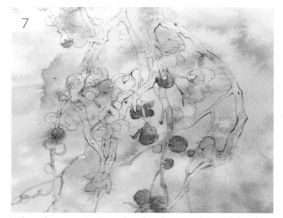

7

When the paper is dry, color the clear petals in solid red.

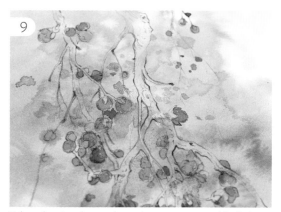

8

To present the petals in the background, mix a little ultramarine violet in the color to distinguish the flowers in the foreground from those in the background.

9

When drawing the petals on the upper parts, add a little ultramarine to distinguish them from the color in the center of the picture.

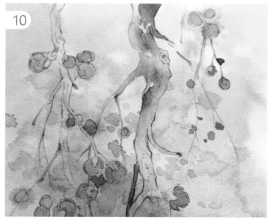

Draw the branches in ultramarine violet, brown, and a little ultramarine, giving the turning parts varying colors.

The thinner branches are painted in brown mixed with a little ultramarine. Make sure not to draw in the same color. When the branches turn, a little ultramarine can be added.

The color of the small branches at the turning point should also be different. Make it a little darker at those turning points.

When the branches are completely dried, draw the details of the lines on the branches with a No. 6 sable brush dipped in light ultramarine.

The twists on the thicker branches can be drawn according to the line sketch, making sure the darkness of the color is different.

Darken the color of the main petals in crimson with high saturation to present the dimensions of the petals. The painting is complete.

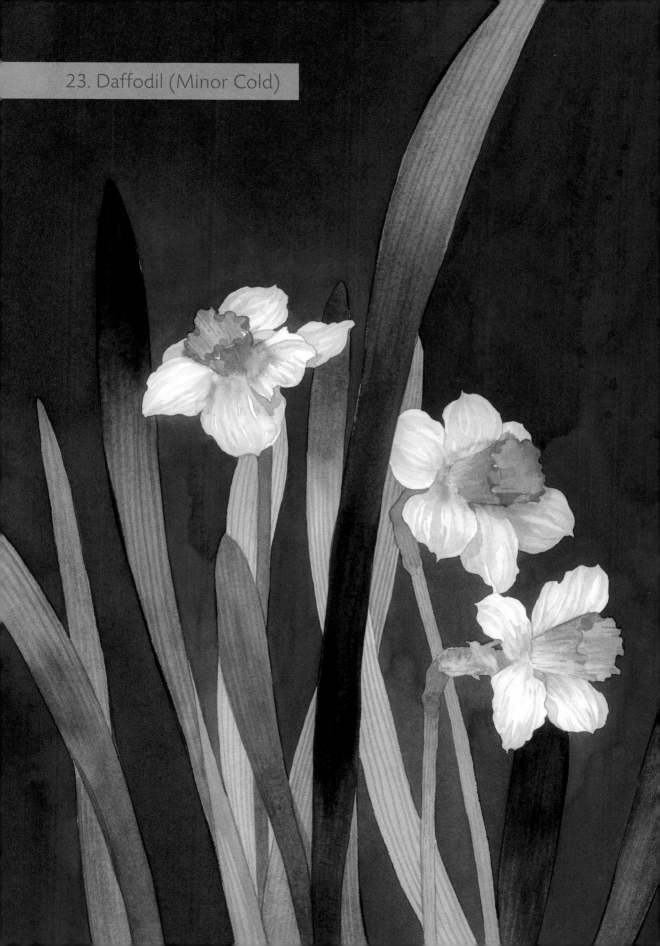

Minor Cold is between January 5 and 7 every year, marking the coldest days of the year when the daffodils quietly blossom. The daffodil has a long history in China. It is one of the traditional ornamental flowers and ten most famous Chinese flowers. The Chinese daffodil is unique in natural beauty and fresh fragrance, extraordinarily refreshing and elegant. Since ancient times, people have regarded it as one of the "four elegant flowers," along with the orchid, chrysanthemum, and calamus, and as one of the "four friends in snow" with plum blossom, camellia, and winter jasmine. People often nurture daffodils to celebrate the new year, adding a touch of elegance to the lively Spring Festival (sketch on page 132).

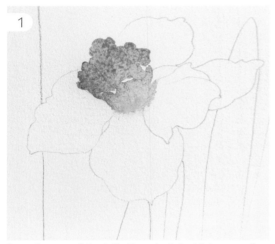

Draw the core of the daffodil on the left with lemon yellow as the base. Mix cadmium red on the top half of the core while it is wet.

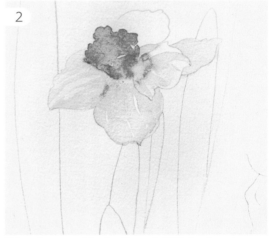

When the core of the first flower is 70% dry, draw the petals with a No. 6 sable brush in very light blue. Do not worry about the color that oozes out of the core, as it will form a natural color mix.

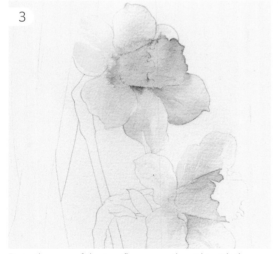

Draw the core of the two flowers on the right with the same steps as the first flower. All the flowers are mixed with a little green on the petals near the root of the flower core.

Draw the long, thin leaves of the daffodil in dark green and phthalo blue.

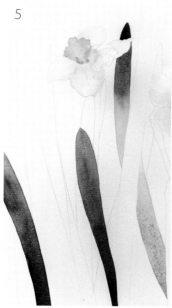

5

Blend phthalo blue and yellow to draw the leaves in different shades of green to make the colors rich and harmonious.

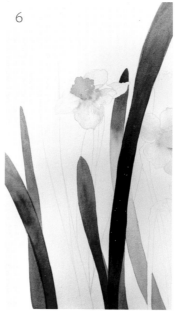

6

The color of the sheltered leaves should be painted in bluish and quieter colors, while the leaves near the center should be brighter to distinguish between the bright and the quiet colors. You can blend a little ultramarine and crimson into the root of the leaves to darken the green.

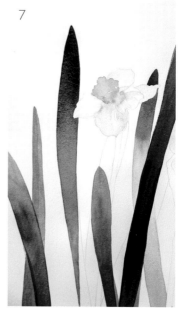

7

Draw the third leaf from the left in bright phthalo blue and green.

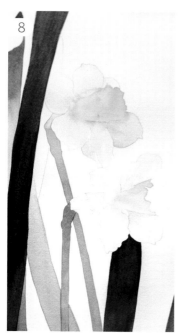

8

Draw the slender flower stems in turquoise and light green, mixing more lemon yellow near the flowers.

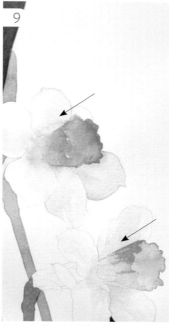

9

Draw the layers of the flower core in red orange, then where indicated by the arrow, add water and slowly color it from top to bottom.

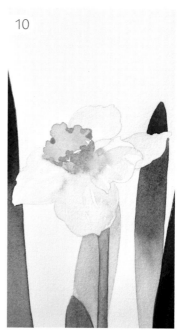

10

The wavy edges of the flower cores are also drawn in red orange.

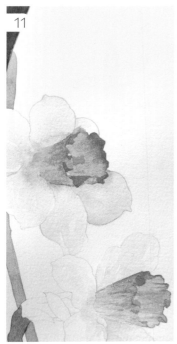

Gradually add more red orange.
The core of the lower flower can
be painted with added coral red to
present the dimensions.

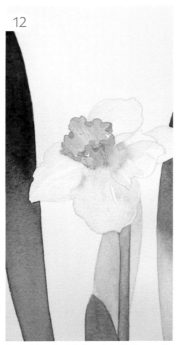

Dip a No. 6 sable brush in light coral
red to draw the details of the left
flower core.

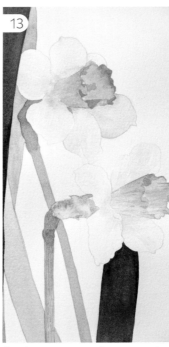

Continue to connect the stems and
the flowers in light green.

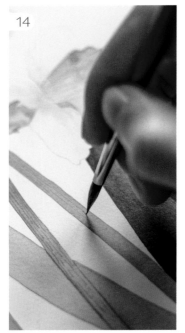

After all the colors are dry, dip a No. 4
sable brush in the remaining bluish
green on the palette and draw the
line details of the flower stems.

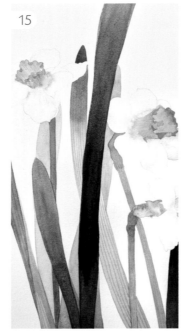

Continue to draw the veins on the
blades with a small brush.

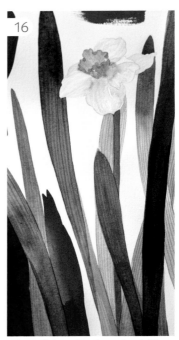

When all the colors have dried, fill in
the background with ultramarine to
highlight the light color of the daffodil
petals to render the picture a classical
touch. The painting is complete.

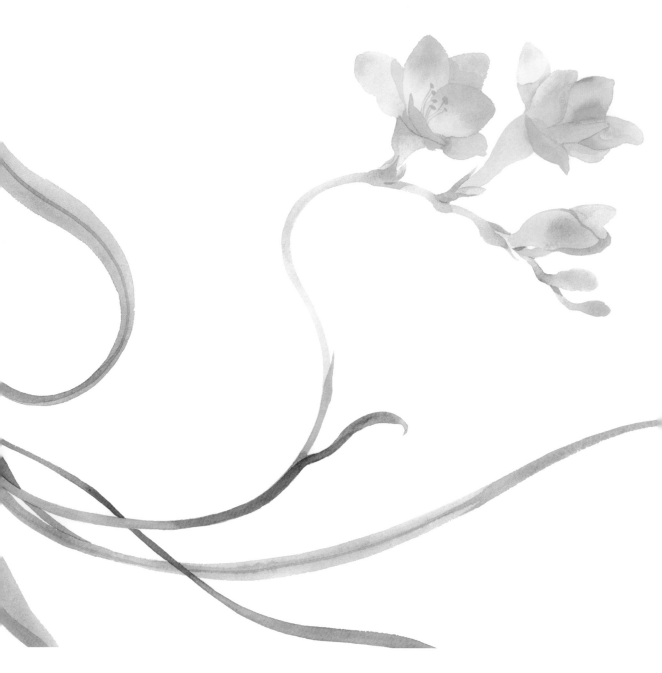

24. Freesia (Major Cold)

Major Cold, the last solar term, is around January 20 every year, when it is freezing cold across the nation and the snow has not yet melted. At this time, it is a sign to the Chinese people that the Spring Festival is coming. People are busy taking down old decorations and creating new ones, creating a joyful festive atmosphere.

Freesia is a beautiful flower, graceful and refreshing, rich in color and elegant fragrance. As it blossoms during the Spring Festival, the off-peak blooming season, it is very popular and often used as a potted flower to decorate the sitting room and the study (sketch on page 132).

1

Mix a little yellow with coral red to draw the shape of the freesia petals.

2

Tinge the tip of the petals with a little red orange and coral red.

3

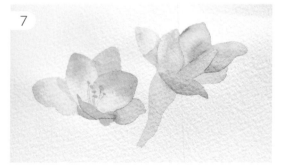

When the paper is 70% dry, dye petal tips again with rose red. Draw the second flower in the same way.

4

In drawing the second flower, add a little more rose red.

5

On the two flowers, mix cadmium yellow with coral red to draw the tiny shadow of the petals, drawing the core part of the right flower with more yellow.

6

Dye the specific petal details of the two flowers in coral red and darken the color of the part where the petals turn and block each other.

7

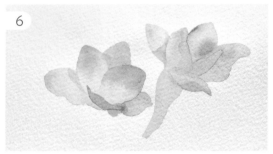

On the left flower, dip a No. 4 sable brush into the light cadmium yellow to draw the stamen.

8

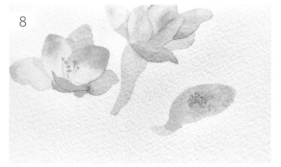

The bud of the freesia is also painted in cadmium yellow and a little cobalt violet to render more texture.

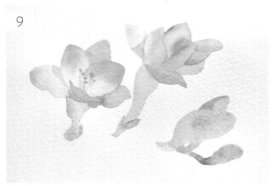

9

Use lemon yellow and a little leaf green to draw the buds that are not yet burgeoning, adding more green to the part near the flower stem.

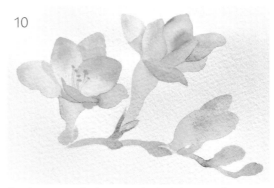

10

Continue to mix leaf green with a little lemon yellow to draw the flower stem to connect the flowers.

11

Steadily and quickly draw a smooth flower stem with a No. 6 sable brush to present a beautiful S-shaped curve. Don't hesitate while drawing, as the lines will look smooth when boldly drawn.

12

Add a little phthalo blue to extend the leaves on the flower stem when it is wet.

13

Draw the remaining leaves in green with more water content and make sure the shape of the leaves correspond to the flower stems.

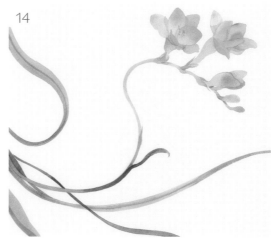

14

Add one more leaf on the upper left to correspond to the S-shaped stem. The painting is complete.

SKETCHES

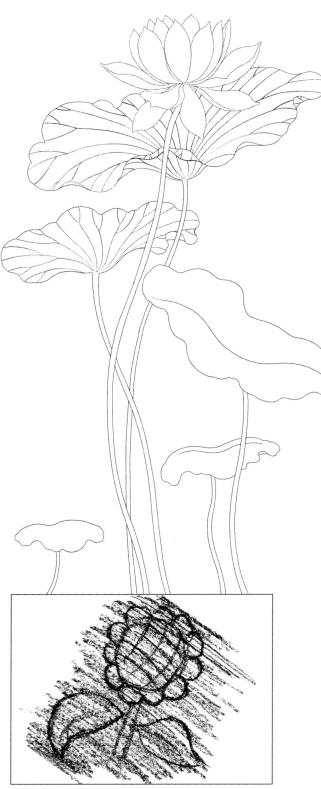

The sketches part arranges the line drafts of 24 tutorials according to the order in the book. You can follow the line drafts and draw on your own. You can also simply transfer them in steps as follows:

1. First, lay a piece of translucent paper on the book and depict the line draft. (You may also use a photocopier which can send electronic file to enlarge the line draft to your ideal size first.)

2. Turn the translucent paper to the back, and you can see the lines on the front. Use a pencil to fill in the traces.

3. Lay the translucent paper on top of the watercolor paper, with the line drawing facing up and the pencil drawing facing down.

4. Use a pencil to trace the lines on the translucent paper again. The line draft will be easily copied to the watercolor paper.

Front of translucent paper. Line drawing.

Back of translucent paper. Pencil drawing.

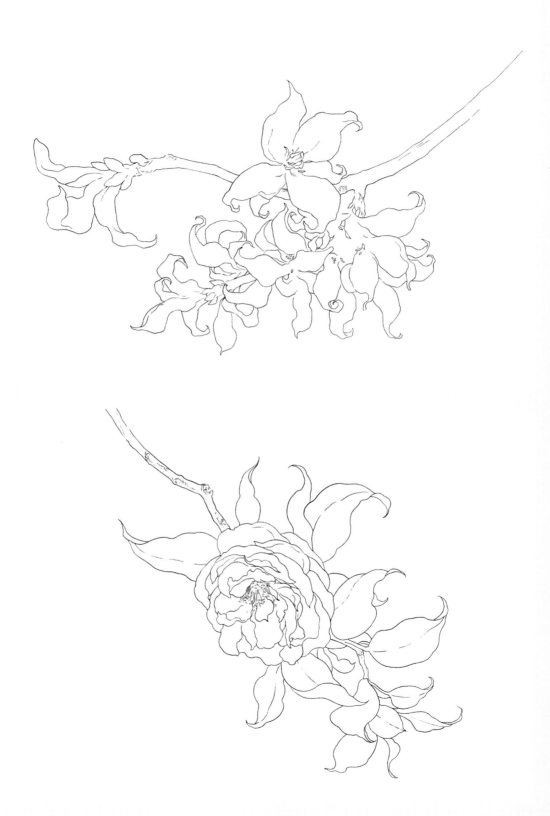

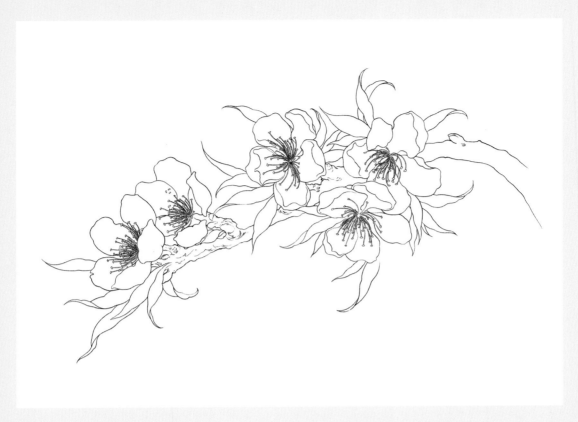

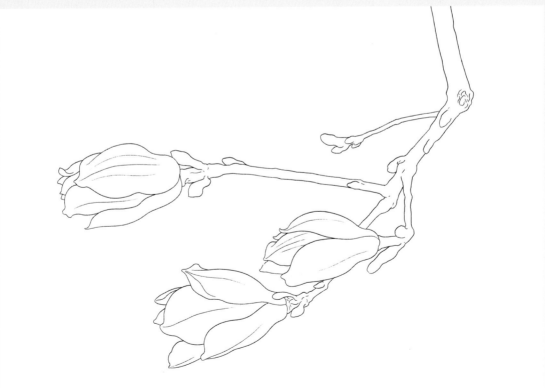

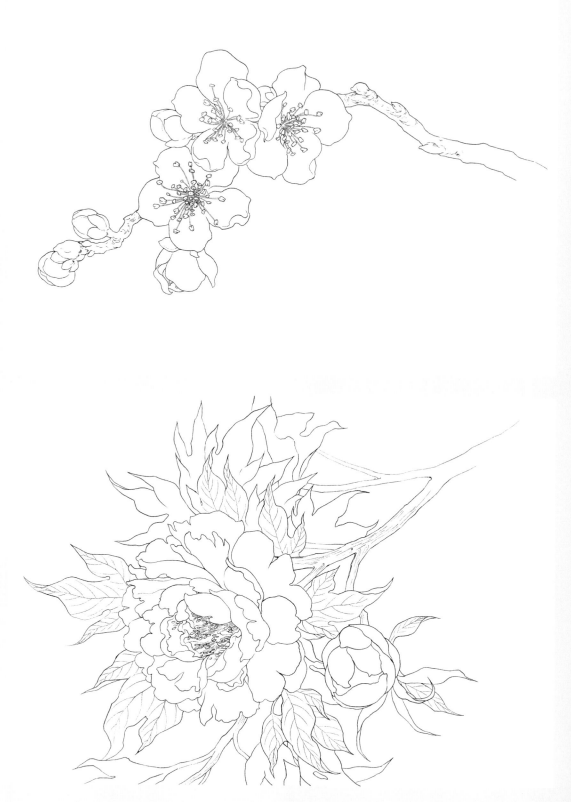

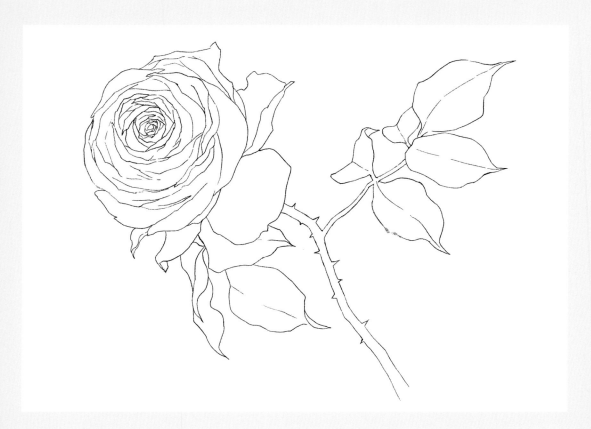

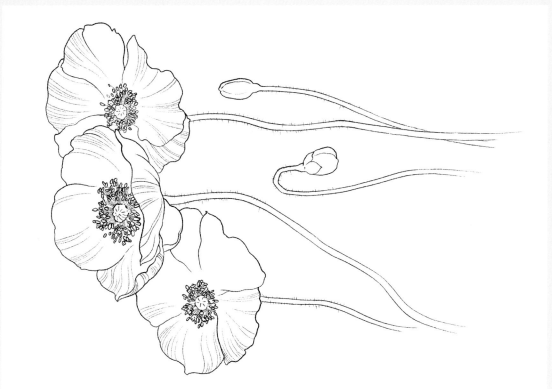

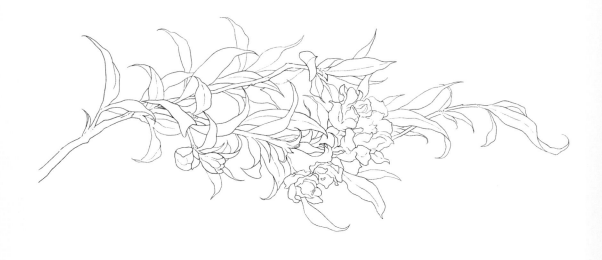

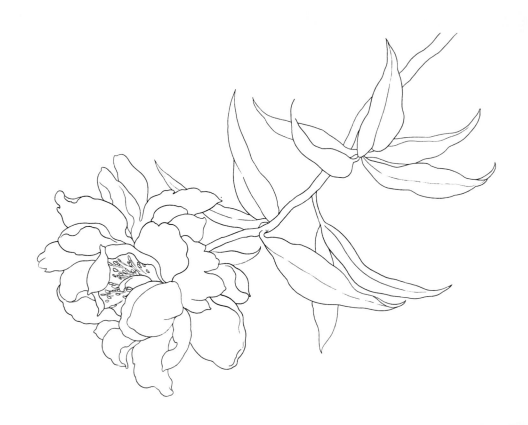

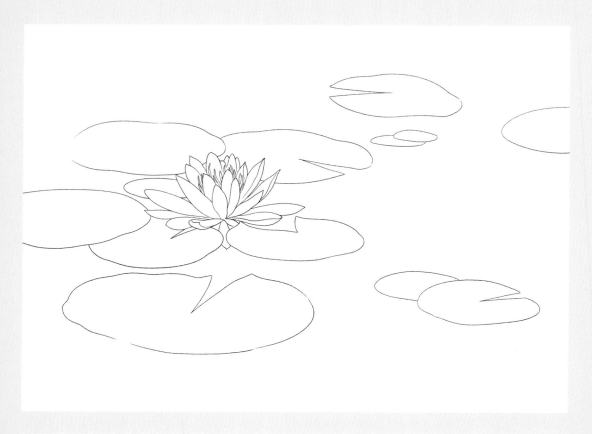

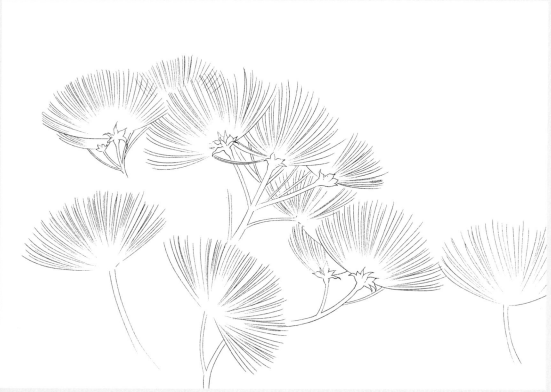

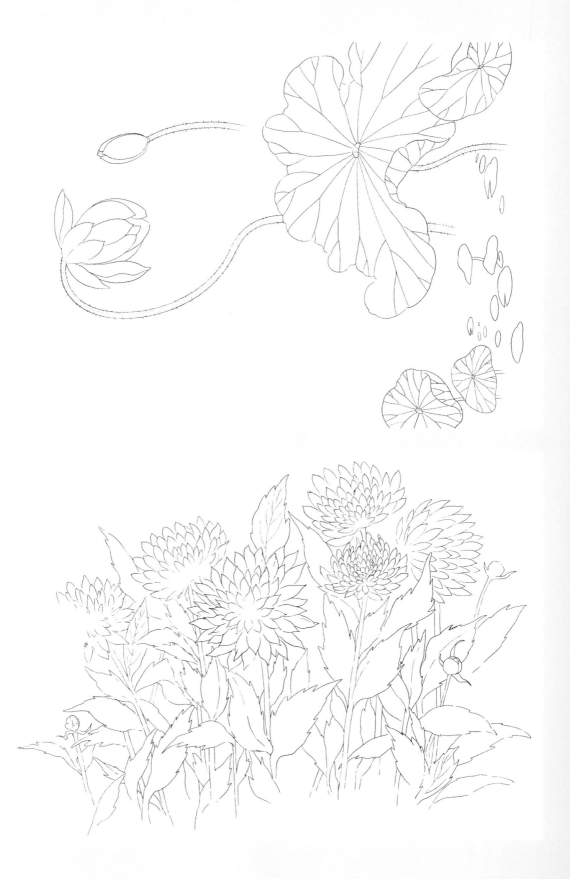

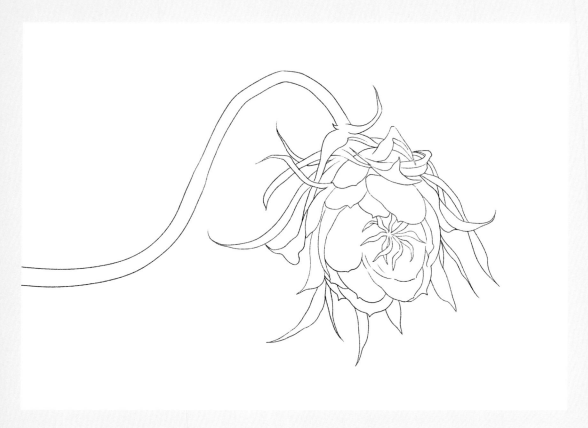

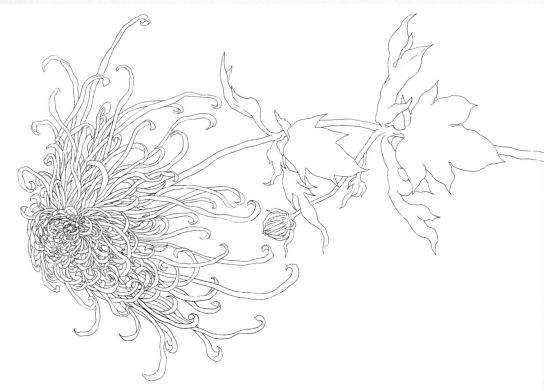

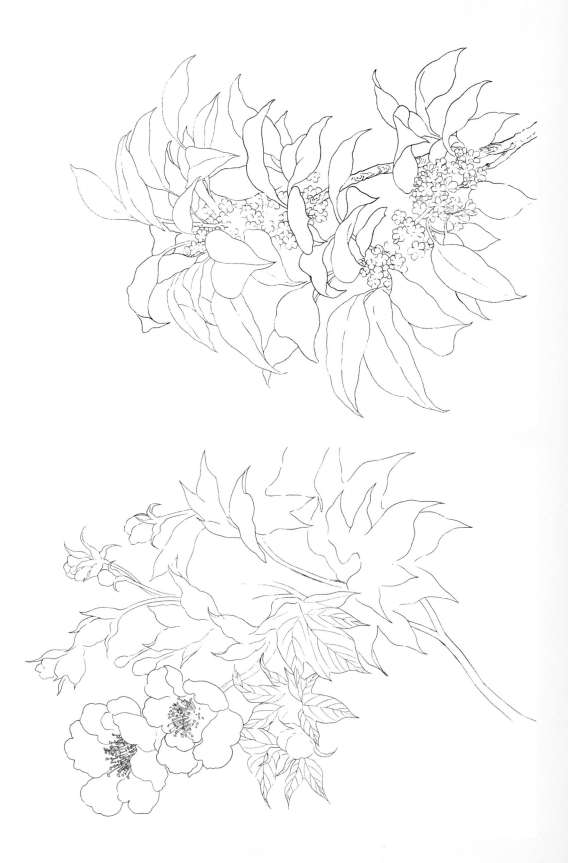

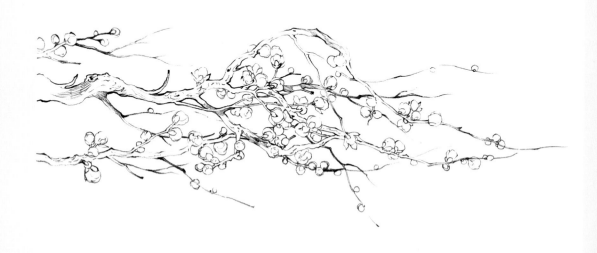

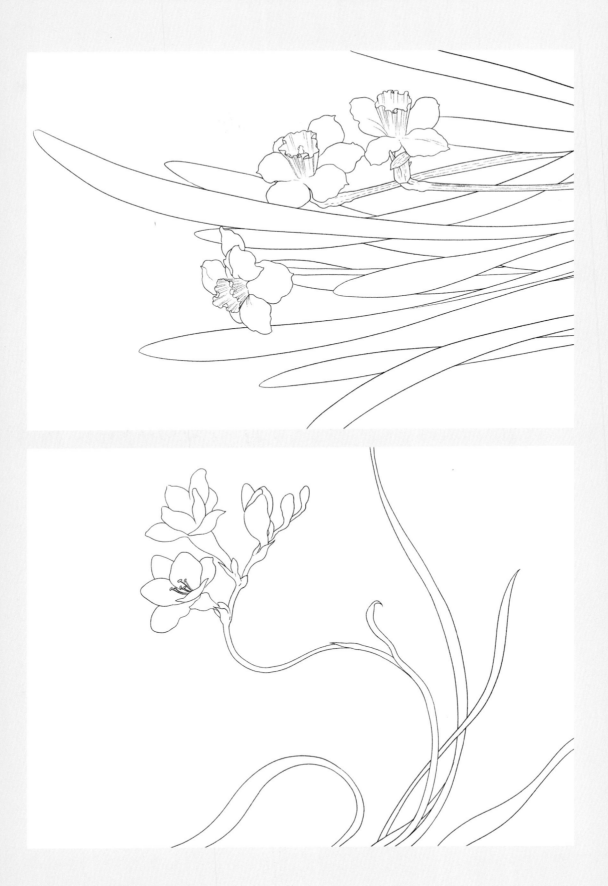